DIY Watercolor Flowers

DIY Watercolor Flowers

The beginner's guide to flower painting
for journal pages, handmade
stationery and more

Marie Boudon

sewandso

www.sewandso.co.uk

Contents

CHAPTER 02
Plant directory

CHAPTER 03
Floral compositions

Foreword

This book is designed for people who, like me, love modern, vibrant and spontaneous watercolors and are hypnotized by the beautiful colors and textures of flowers.

I wanted to create a proper step-by-step guide for you, rather than just a series of tutorials. We'll look at how to choose your color palette, flowers and composition, seek contrast, perfect your brushwork and so on, as we work on many different subjects to achieve magical results.

Unleash your creativity and savor the joy of seeing water and pigments blend together. Dive right in without looking critically at your initial results; the important thing is to have fun. I find painting watercolor flowers takes me out of myself and relaxes me. You'll gain confidence over time!

I'd be thrilled to see your creations, so tag me on Instagram (@tribulationsde-marie, #fleursaquarellemarie)!

Marie

Follow me:

Website - tribulationsdemarie.com
Instagram - @tribulationsdemarie
Email - contact@tribulationsdemarie.com

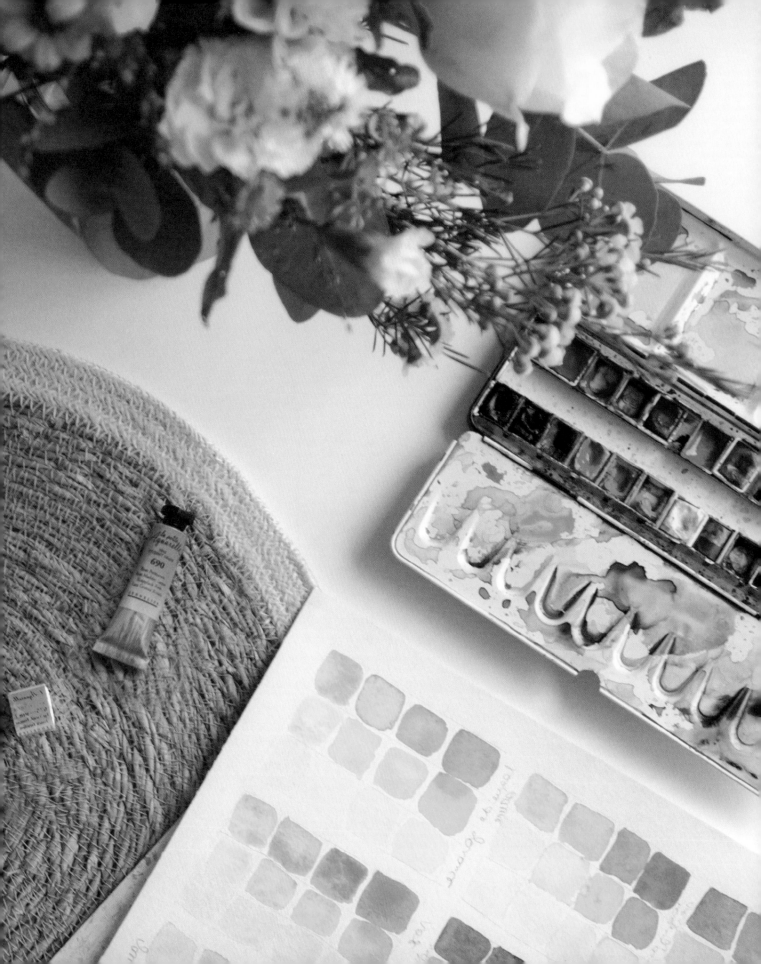

Basic techniques

BEFORE STARTING TO PAINT FLORAL COMPOSITIONS, LET'S REVIEW THE BASIC TECHNIQUES.

THROUGHOUT THIS CHAPTER, I'LL SUGGEST LITTLE EXERCISES FOR YOU TO FAMILIARIZE YOURSELF WITH WATERCOLORS. TAKE TIME TO GET TO KNOW YOUR EQUIPMENT AND TRY OUT THE EXERCISES. THAT WAY YOU'LL END UP PAINTING PLANTS WITH EASE.

I REGULARLY PRACTICE LITTLE WARM-UP EXERCISES BEFORE LAUNCHING INTO A CREATION. IT FILLS ME WITH CONFIDENCE.

Equipment

You'll need very little equipment to get started with watercolors and create your floral compositions. Here's the list of essentials:

8 to 12 colors

a soft brush that holds water well

a small round pointed-tip brush

watercolor paper

a clean palette

a water jar

a cloth

masking tape

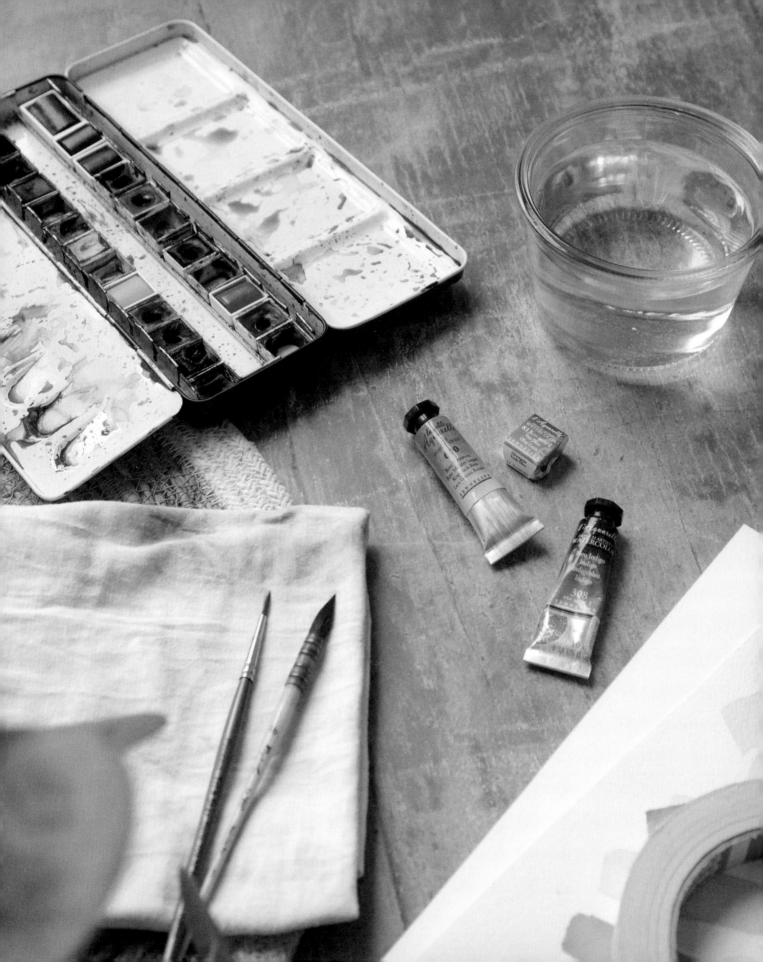

Paint

FORMAT

Watercolors are available in several different formats: pans, tubes, pencils, marker pens, ink, etc. To start with, I'd recommend that you use pans. These are little blocks of compressed paint in a solid state. Watercolor tubes contain liquid paints. They're more difficult for a beginner to control as you risk getting too much on your brush and therefore losing the transparency of watercolor. Keep tubes for more advanced use, when you know which colors you prefer; then they're more economical.

QUALITY

There are two levels of quality for watercolors: fine and extra-fine. Extra-fine watercolor contains more pigment and purer, better quality pigment. It is therefore more expensive but also more vibrant, luminous and intense. In my opinion, pans of fine watercolors are a suitably inexpensive way of discovering the medium and having fun.

SETS

To start with, you can buy a 12-pan set of fine watercolors. Replace the white with pink, as white is pointless with watercolors (the paper acts as white). Small sets rarely contain pink, a color you can't "produce" with red and white, and it's useful for painting flowers. With practice, you'll quickly identify your favorite colors, or the colors you're lacking, and can add them to make up your own customized set, possibly including some extra-fine watercolors.

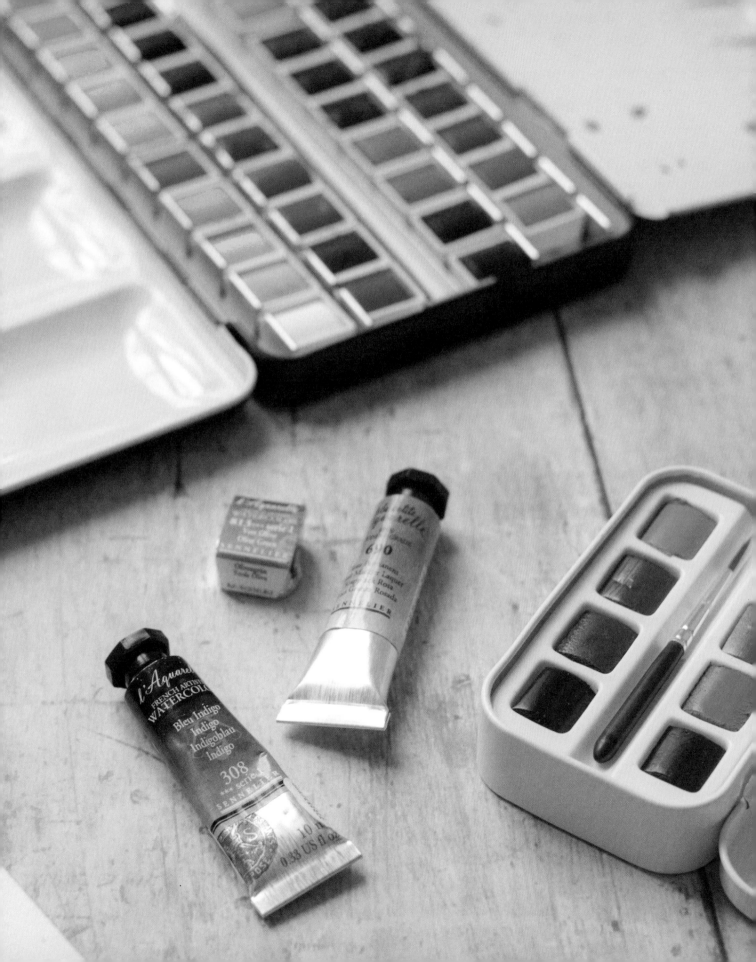

Brushes

I advise that you have two brushes for your floral compositions: a squirrel-hair or synthetic wash brush (soft, to hold water well), and a small round pointed-tip brush.

For my squirrel brush (or wash brush) I use a Raphaël No. 00 (2/0) from the 803 range. It holds water really well and allows plenty of freedom for expressive brushwork. For my small round pointed-tip brush, I use a synthetic Golden Taklon Tri-Star No. 6.

Opt for a standard brush, with either natural or synthetic bristles, rather than a paintbrush with a water reservoir. I find that standard brushes mean you work with the right amount of water more accurately, which is an essential skill in watercolor painting. A standard brush also lets you work separately on your brushstrokes and the amount of water to use for best effect, whereas brushwork is more complicated with a built-in reservoir because you have to press on the brush and continue painting at the same time. A brush with a reservoir is very useful for painting outdoors in particular, but for the type of practice that I suggest in this book, a standard brush is more appropriate.

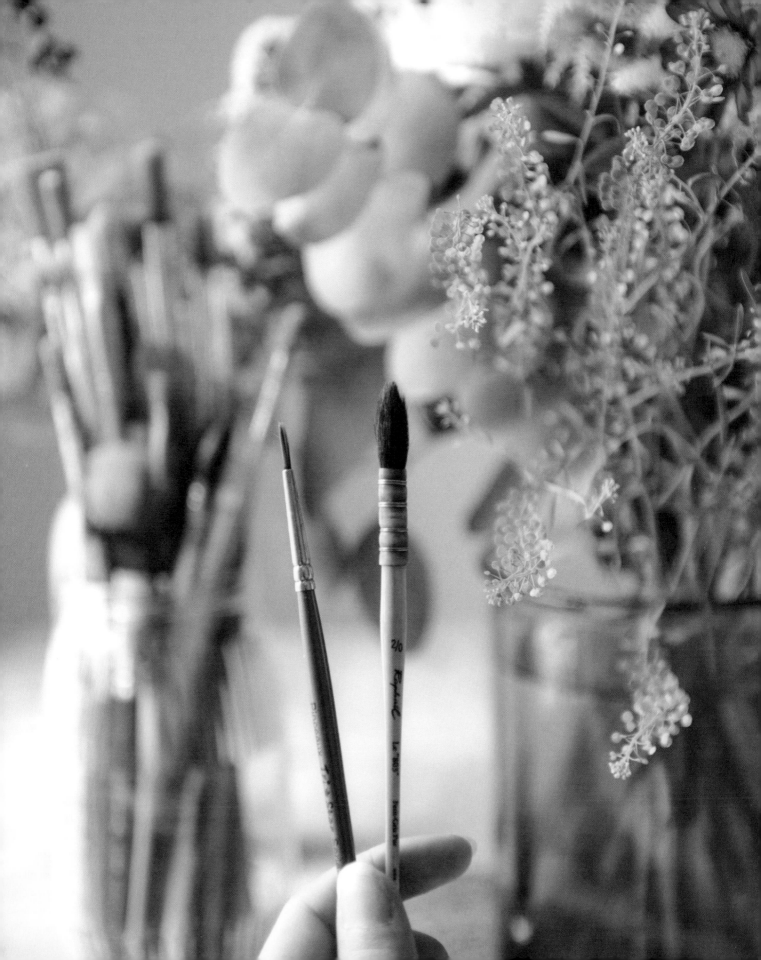

Papers

WATERCOLOR PAPER IS THICK, SO IT CAN SOAK UP A LOT OF WATER WITHOUT BUCKLING. THE STANDARD WEIGHT FOR A SHEET OF WATERCOLOR PAPER IS 300 GR/M².

QUALITY

There are two choices in terms of quality: 100% cellulose or 100% cotton. The former is more affordable, and I would advise you to start with that. Paper made from 100% cotton allows you to do wet-on-wet work for longer. However, it leaves less room for error as the color soaks deep into the cotton fibers, so it is more difficult to make corrections.

TEXTURE

There are several types of texture for watercolor paper: hot pressed, cold pressed and rough. Rough has the coarsest texture and hot pressed is the smoothest. I prefer cold pressed because its texture is neither too smooth nor too pronounced. I find it the easiest to use.

FORMAT

Watercolor paper comes in books, blocks or sheets. To start with, I recommend a block of paper, if possible glued on all four sides and measuring 24x32 cm or equivalent. This format allows freedom of movement in your brushwork. In my view, for floral compositions it is more appropriate than a small A5 format.

A book is also a good idea, but I sometimes feel restricted as I try to create a sense of harmony with the previous pages. Sheets, often in 56x76 cm format, are more economical but you have to cut them to size, avoiding leftover scraps. It is therefore less practical when you're a beginner.

I recommend starting with Moulin du Coq, "Le Rouge", 100% cellulose paper. For 100% cotton, I really like Langton Prestige.

GETTING TO KNOW
your colors

COLOR PALETTE IS A PERSONAL CHOICE, TO SOME EXTENT. AS YOU PRACTICE, YOU WILL IDENTIFY YOUR FAVORITE COLORS. ALTHOUGH IT'S STILL DEVELOPING, HERE'S HOW I SELECTED MY PALETTE.

I love painting quickly, so I use certain ready-made mixes such as green, orange-yellow, sepia, etc. That saves me time.

My favorite subject, flowers, and my personal tastes lead me to broaden my palette with different shades of blues, pinks and greens (I avoid ochres).

Some pigments are more transparent than others. The degree of transparency will be indicated on the packaging (☐ transparent, ◩ semi-opaque or ◼ opaque). I favor transparent pigments for getting lovely overlay effects, but I also love opaque and semi-opaque pigments as they are more concentrated and provide a beautiful contrast.

I don't use a white pan as the paper acts as the white in watercolor painting. I use a little black (Payne's Gray), mainly for the center of anemones and to get deep shades of burgundy and violet quickly. The rest of the time, I like to create my own black from indigo or sepia, or by mixing together the three primary colors.

MARIE'S COLORS

(Sennelier extra-fine professional quality)

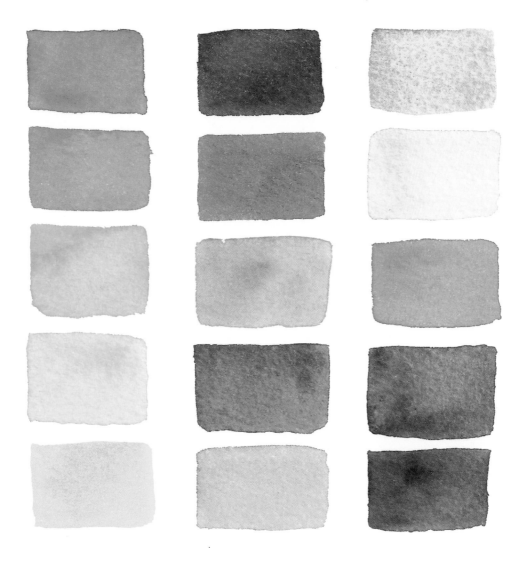

Carmine Red

French Vermilion

True Deep
Cadmium Yellow

Quinacridone Gold

True Cadmium
Lemon Yellow

Indigo

Phthalo Turquoise

Veronese Green

Forest Green

Sap Green

Deep Cobalt Blue

Rose Madder Lake

Opera Rose

Payne's Gray

Raw Sepia

: my essentials

COLOR CHART

Having assembled the colors, we're going to get to know them better, in particular how they react with water. To get to grips with water, we're going to create a color chart showing three samples for each color in the palette: pure color, diluted and heavily diluted (see example opposite).

1. To prepare for the exercise you can draw a grid, using a lead pencil.

2. Load your brush with an initial color. Paint the first square, then dip your brush in water. Gently squeeze out the surplus water on the rim of your jar and paint the second square.

3. Repeat to dilute your color a bit more and paint the final square.

This process is not as easy as it may seem. You will either be tempted to avoid rinsing your brush for fear of spoiling the paint, or not put enough paint on your brush at the start.

1 /
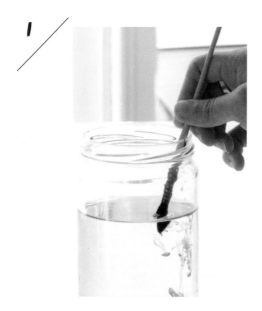

Dip the brush in the water without stirring.

2 /
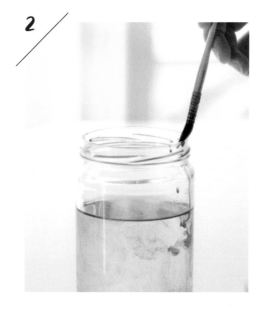

Press the brush head against the rim to squeeze out the water.

| Pure color | Diluted | Heavily diluted | Pure color | Diluted | Heavily diluted |

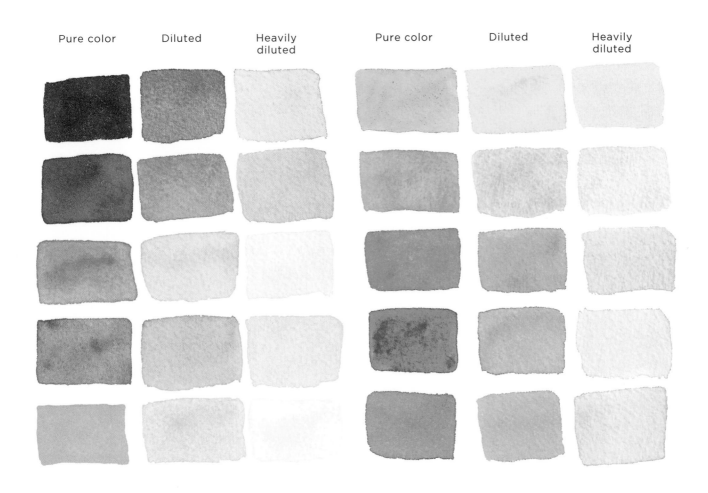

NOTE THE NAMES OF YOUR COLORS OR NUMBER THEM TO MAKE IT EASIER TO MEMORIZE YOUR FAVORITE MIXES.

BROADENING YOUR RANGE OF COLORS

Diluting pure colors with water gives you a wide range of tints. With the previous exercise, we worked with the values, or tonal range, for a single color at a time. However, there are other methods of widening a color range without buying more pigments. This exploratory work enables you to obtain an infinite number of tints to add depth and contrast to your compositions.

Values

The value represents the varying degree of lightness of a color. The value scale is very wide, ranging from deep black to the whiteness of the paper. Pure colors have different inherent values: for example, lemon yellow is lighter than indigo blue. You can also have a single color with different values: light, medium and dark.

• To get a lighter color, add water (see previous page).
• To get a darker color, add black.

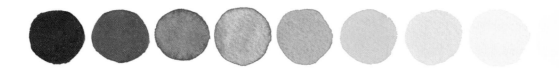

IN THE CENTER IS THE PURE COLOR, WITH LIGHTER VALUES TO THE RIGHT, OBTAINED BY DILUTING WITH WATER, AND DARKER VALUES TO THE LEFT BY ADDING AN INCREASING AMOUNT OF BLACK.

Saturation

Saturation, or color strength, represents the purity of a color. To desaturate a color, you just need to add a varying amount of a neutral gray tone and water. Take care adjusting the amount of water to ensure that you retain the same value and only vary the purity of the color.

Practice varying the saturation and value of your colors to enrich your palette with an infinite number of new tints. The color or mix chosen for black and gray (warmer or cooler variations) has a major impact on the end result. I personally often choose Raw Sepia or Payne's Gray to desaturate or darken a color (see my favorite mixes on page 28).

EXPERIMENTING

with mixes

NOW THAT YOU HAVE A GOOD COMMAND OF COLORS AND THEIR VARIATIONS, YOU'RE GOING TO LEARN HOW TO PRODUCE MIXES TO OBTAIN A RICH, UNIQUE PALETTE.

PRODUCING A MIX

I often make mixes with two colors but rarely more than two. I also prefer to make a mix several times rather than making a large quantity of it once. With a bit of practice, it's easy to add the precise amount of pigment to get the same color again. Here's how I do it:

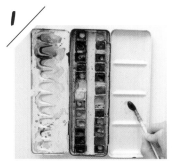

1/ Wet the brush, sweep it over the first pan and transfer the color to the palette.

2/ Without rinsing the brush, pick up a second color.

3/ Deposit the second color on the first and mix them together. Test the result either directly on the palette or on a piece of rough paper.

My advice!

It's not worth cleaning your palette after each use; re-use a dried mix by adding a bit of water.

Separate cold colors and warm colors into different areas of your palette to avoid forming drab grays or browns.

I clean my palette by holding it under the tap and cleaning it with a big brush, taking care not to wet my pans.

YOUR TURN TO MIX! CHOOSE TWO COLORS AND MIX THEM IN TWO DIFFERENT WAYS.

Color 1 Color 1
+ a bit of color 2 Color 2
+ a bit of color 1 Color 2

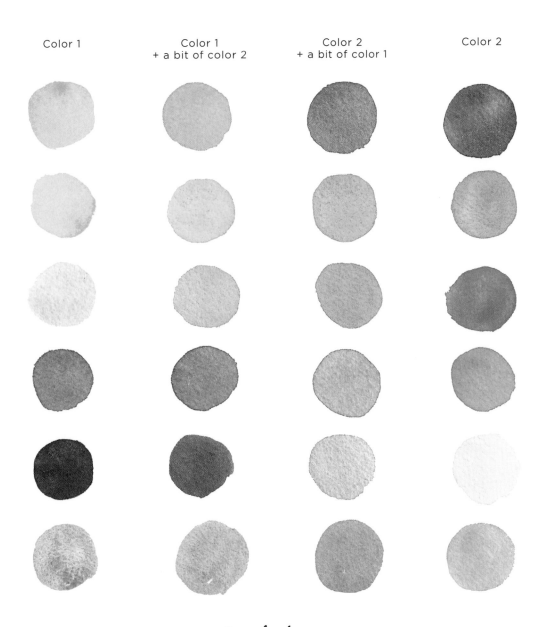

Examples of mixes

Marie's favourite mixes

Here are some of my favorite mixes. These are just an indication of what you can create. If you haven't got exactly the same colors as me, it doesn't matter. Sometimes, I make the following mixes with different concentrations of colors and water. Practice achieving these or similar colors. I suggest that you make a color chart of them on a separate sheet, as it may help you to carry out each step of the Floral Compositions chapter.

 Lemon Yellow + Sap Green

 Rose Madder Lake + Cadmium Yellow

 Indigo Blue + Raw Sepia

 Forest Green + Raw Sepia

 Carmine Red + French Vermilion

 Deep Cobalt Blue + Rose Madder Lake

 Forest Green + Lemon Yellow + Raw Sepia

 Cadmium Yellow + Quinacridone Gold

 Opera Rose + Carmine Red + Payne's Gray

 Lemon Yellow + Sap Green + Raw Sepia

 Phthalo Turquoise + Veronese Green + Raw Sepia

 French Vermilion + Cadmium Yellow

 Sap Green + Raw Sepia

 Lemon Yellow + Cadmium Yellow + Raw Sepia

 Deep Cobalt Blue + Opera Rose

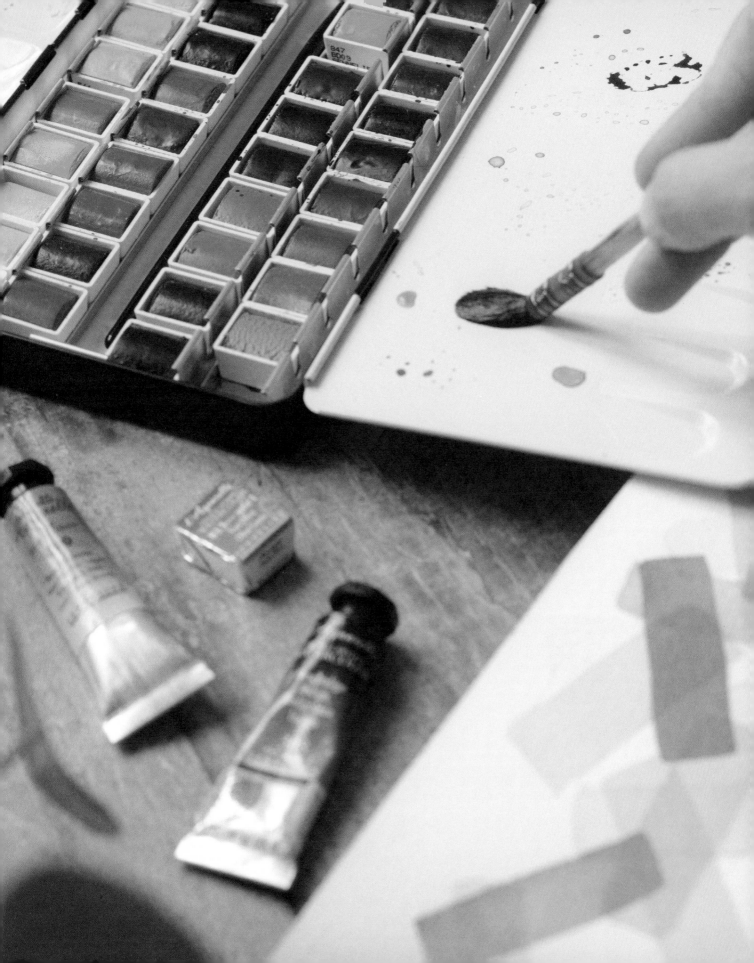

CREATING A

palette

STUDYING THE COLOR WHEEL

Choosing a palette of well-balanced colors is essential for a successful composition. It's not straightforward, but with a few tips, you'll manage it more easily.

First, let's study the color wheel. It is made up of the three primary colors (red, yellow and blue), three secondary colors (orange, green and violet) and six tertiary colors. Complementary colors are positioned opposite each other on the color wheel (e.g. red and green).

Don't forget that each pure color has its own tonal range (different levels of saturation or color strength) and values. A brown is therefore a dark shade of orange and a beige is a desaturated yellow.

Certain color schemes on the color wheel offer particularly interesting palettes.

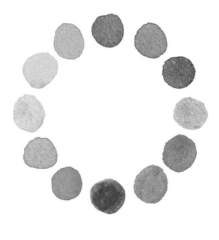

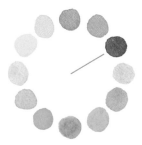

Monochrome palette

This palette shows a single color with its variations in tone (level of saturation), tints (addition of water) and shades (addition of black).

For example:

Analogous palette

The colors sit alongside each other on the color wheel. The composition immediately looks harmonious.

**For example
(see Foliage frame on page 106):**

Triadic palette

The colors sit in a triangular arrangement on the color wheel.

**For example
(see Violet circlet on page 116):**

Tetradic palette (or double-complementary)

The colors form a rectangle on the color wheel. Two pairs of complementary colors have been selected.

**For example
(see Peony pattern on page 136):**

Analogous complementary palette

To create this type of palette you need to select a color and its complementary color, then add analogous colors for one of the two principal colors.

**For example
(see Colorful bouquet on page 126):**

NUMBER OF COLORS AND VALUES

When preparing your floral composition, count on having about six colors of different values.
• One or two dark colors,
• one or two light colors,
• two or three medium colors.

Having a wide value scale will add contrast to your composition. Take a look at the examples below.

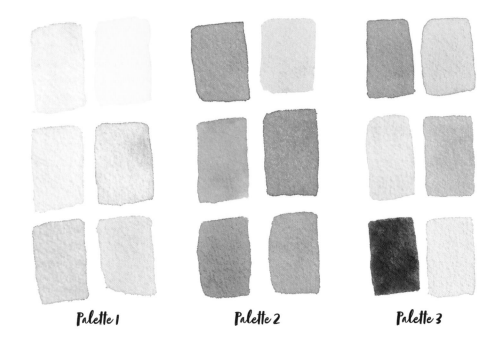

Palette 1 Palette 2 Palette 3

I began by drawing my inspiration from a tetradic scheme (double-complementary) for the choice of colors: green and red, yellow-green and red-violet. I used this scheme as a guide but also added other colors of my choice such as, in this case, blue. The objective is to have fun and experiment!

I make use of little colored samples that I've produced over the course of my research to get a better idea of the end result.

The first two palettes reflect the two common problems experienced by beginners.
• Not daring to use their pans and getting washed out colors (Palette 1).
• Using their pure colors like gouache and ending up with a result that is too saturated (Palette 2).

By modifying the value and saturation level of some of the chosen colors, I get a more balanced palette (Palette 3). I've darkened the pink, desaturated the blue and lightened the orange-red.

WET AND DRY
techniques

WHAT MAKES WATERCOLOR DISTINCTIVE IS THE WAY IT WORKS WITH WATER. WATER ALLOWS YOU TO DILUTE, AND OVERLAY PIGMENTS FOR A DIFFUSED EFFECT. IT ALSO LETS YOU ACHIEVE UNIQUE EFFECTS THAT ARE DIFFICULT TO REPLICATE.

There are two main techniques for using water when painting with watercolors.
• Painting with a wet brush on dry paper, known as the dry technique or "wet-on-dry".
• Painting with a wet brush on wet paper, known as the wet technique or "wet-on-wet".

The water comes from the paper and/or the brush.

To produce the floral compositions in this book, we are going to work mainly using the dry technique. The paper will not be moistened beforehand, which increases the level of precision.

We will also use the wet technique to achieve some lovely color gradation or blending.

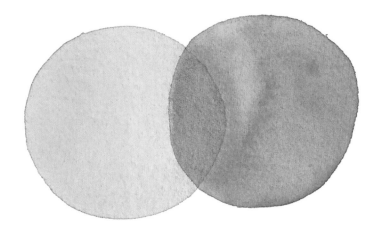

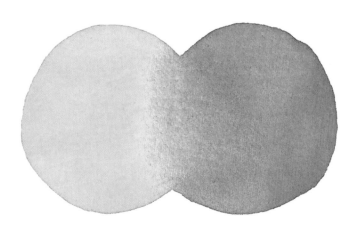

TWO TECHNIQUES FOR TWO VERY DIFFERENT RESULTS:
WET-ON-DRY (TOP) AND WET-ON-WET (BOTTOM).

THE DRY TECHNIQUE: TRANSPARENCY EFFECT

The dry technique, or laying down a color on dry paper, notably allows you to achieve superb transparency effects. You just need to put down a thin layer of color onto an already dry color. This is called the glaze.

The overlaying effect allows you to create new darker or more saturated colors than the original one. We will use it to overlay the foliage and give a lush effect to our compositions.

Practice the following exercise to master this technique.

1 /

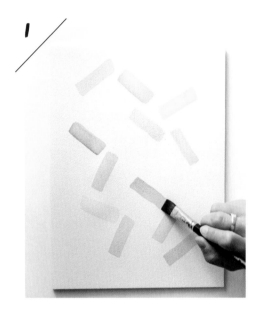

Using a flat brush, paint colored lines (like confetti). Start with the lightest colors (using lots of water).

2 /

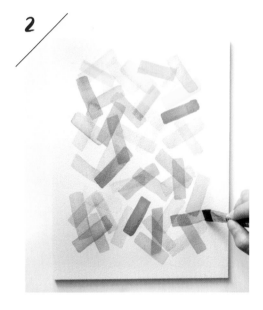

Once the first layer has dried, repeat the process from the beginning, slightly increasing the concentration of pigment in the mixes. Paint the lines in all directions. Look at the lovely colors created through the transparency.

My advice!

**I advise you to overlay a deeper-colored layer on top of a light layer.
If you do the opposite, there is a risk that the dry deep color on the bottom layer will run and the result will not be as neat.**

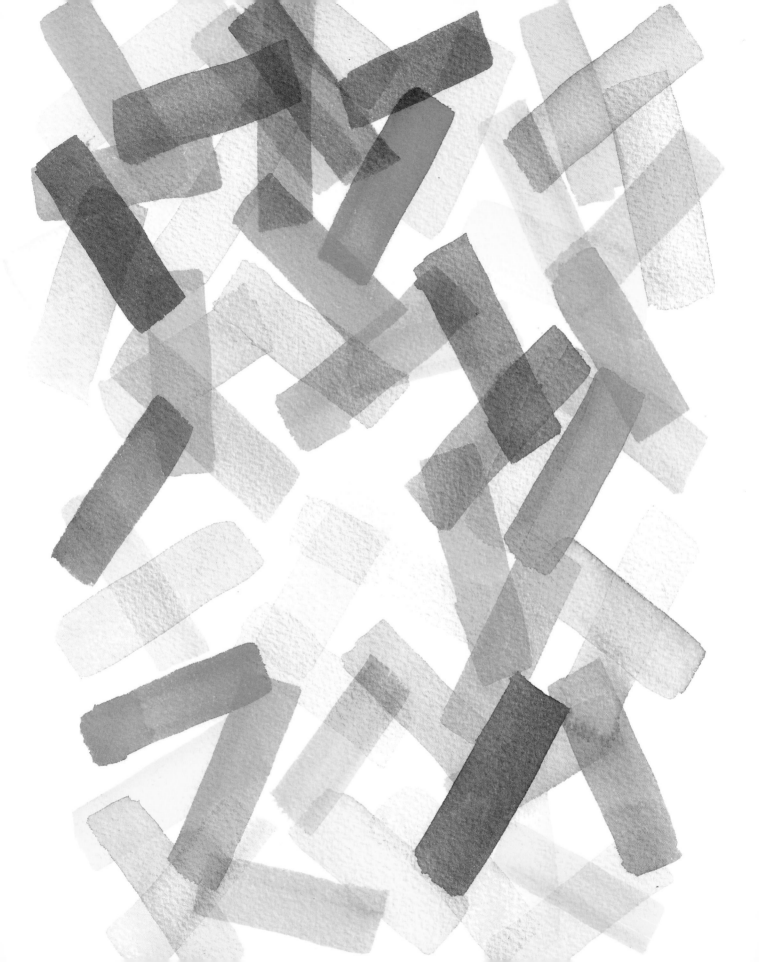

THE WET TECHNIQUE: DIFFUSION EFFECT

Unlike wet-on-dry work, wet-on-wet work involves not waiting for the medium to dry but painting while it is still wet. The colors mix, and unexpected and uncontrollable effects are produced. It is perfect for improving the end result for our flowers and foliage.

Carry out the following exercise to get a better understanding of the wet-on-wet technique.

1

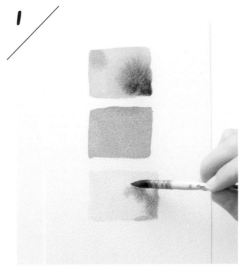

Paint three rectangles, including one using only water. Before they have dried, drop other pigments on the paper.

2

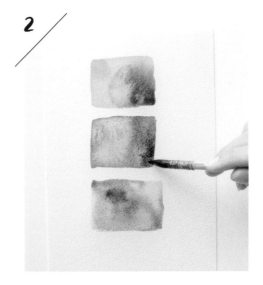

Add deeper pigments, lighter pigments or just water and observe the effects produced.

3

Tilt your paper on its side regularly to get a better view of the extent of drying and interaction at different stages. The ease with which the pigments are diffused will vary.

The following exercise can help you to gain a better understanding of how pigments behave with water.

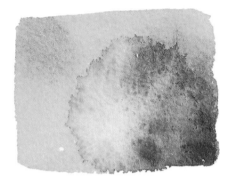

Take a look at this halo effect. The pigmented area was drying out when I added a drop of water. The droplet pushed the pigments to the edge of its diffusion zone and created this halo effect.

To avoid that, pay close attention to how wet your paper is and do not continue working on it if it is not sufficiently wet. This effect often occurs on the edges of a piece of work, where there is a build-up of water that is drying out more slowly than the rest of the picture. You just need to soak it up with a well-squeezed brush.

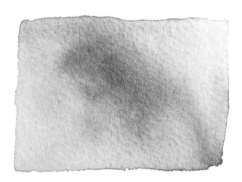

I gradually added pigments to this rectangle of water. On drying out, the result is less saturated than the original pigments. When doing wet-on-wet work, it is better to use concentrated colors as they will become less vivid once dry.

As a specific example, for a floral composition I use this technique to add pigments to the center of my flowers or leaves that have not yet dried out (deep blue in this case) to create lovely intense effects through the diffusion of one pigment into another.

BLENDING AND
gradation

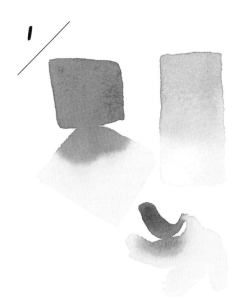

I love using color blending and gradation to get beautiful soft effects for my flowers and foliage. With each brushstroke, I try to change my color to create a multitude of interesting tints.

We're going to carry out four little exercises to familiarize ourselves with the effects of blending and gradation when using watercolors.

1

EXERCISE 1:
GRADATION EFFECT USING WATER

Start painting with concentrated paint that is only very slightly wet. Rinse your brush thoroughly and squeeze about half the water out of it. Continue painting with the wet brush and note the gradation effect that is formed. I often use this method for painting my roses.

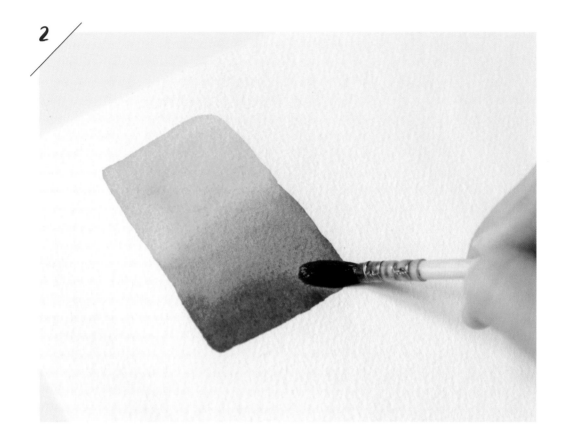

EXERCISE 2: GRADATION EFFECT USING A COLOR

Start painting with a medium degree of wetness. Before the color dries, quickly load your brush with other pigments and continue painting. Do not go back over what you have already painted. Paint in the direction of wet to dry. The pigments will become diffused and mix quite naturally.

3 /

EXERCISE 3: BLENDING AND SHAPES

Paint lines and shapes with colors of different tonal values and pigment concentrations. Allow them to deliberately touch each other and observe the color blends and gradients that are formed.

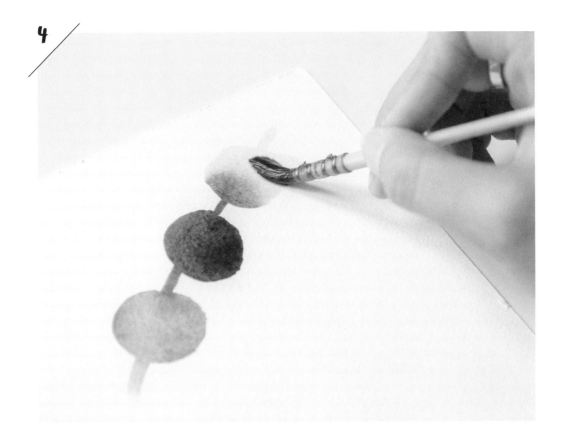

EXERCISE 4: WATER FOR CONNECTING

Using a well-rinsed brush, paint a line. You don't need to use much water. Paint shapes on this line using different colors. The pigments will become diffused via the line and a natural gradation effect will be formed. I frequently use this technique for painting my stems and leaves. The secret to this technique is letting the gradation effect form by itself. Do not rework it with the brush.

CREATING
contrast

FOR YOUR FLORAL COMPOSITIONS TO BE INTERESTING, THEY MUST HAVE CONTRAST. TO HELP WITH THIS, TRY TO INCLUDE THE FOLLOWING THREE TYPES OF CONTRAST.

SIZE CONTRAST

Vary the size of elements you choose for your composition. Select one or two main elements: they will be the biggest. Then select several medium-sized elements and, to finish off, some small elements that will fill in the empty spaces and add interest.

SHAPE CONTRAST

Think about varying shapes to make your floral composition more interesting. In the Plant Directory section, you will learn how to create flowers and leaves with varying shapes. You can also experiment with your brushes to find new shapes to incorporate into your compositions. Here are a few ideas: shapes that are thin, wide, simple, complex, rectangular or round, etc.

COLOR CONTRAST

The arrangement of colors will have a strong impact on the quality of contrast in your composition. Use the advice given in Getting to know your colors (page 20) for a well-contrasted composition. Don't forget to develop a varied range of tonal values (light tones, midtones and dark tones): that is undoubtedly the most important piece of advice as, without a light or dark tone, your composition will appear dull. Avoid painting an even number of elements in the same color, use odd numbers instead. Finally, make sure you do not distribute color too evenly. Try creating a greener area or bluer area, for example, to add dynamism.

EXERCISE

In my view, working on contrast is mainly an exercise in observation. Through practice, you will sense whether or not there are enough little elements and whether the colors are sufficiently balanced, etc.

Try the following exercise for practice: start a pattern-like composition (see page 81) on a full page, without thinking ahead and without doing any rough work, using varied brushstrokes.

Don't think about it too much and vary the size, shape and color to get a harmonious composition with contrast. The picture opposite shows the result I got after 5 to 10 minutes.

KEEPING BRUSHWORK
fluid

Brushstrokes are very important for the floral compositions I suggest in this book. I love to paint with spontaneity and expressiveness.

Sometimes it's a success and other times less so. Watercolor leaves little room for error but with practice, you will gain confidence and your brushwork will become more fluid. As you become familiar with your pigments, paper and brushes, the amount of water you use will become more intuitive, and your compositions will be more successful as a result.

Try the following exercises to encourage freedom of movement in your brushstrokes. Don't try to achieve a perfect result, simply try to "feel" the brushwork and its effects.

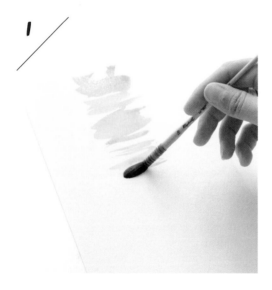
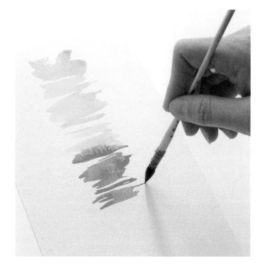

EXERCISE 1: SPEED

Use brushstrokes to paint lines of varying thickness, color and value (light, midtone and dark), working from the top of the page to the bottom. The paint must not have time to dry in order for the lovely gradation effects to appear. That should take you less than 30 seconds!

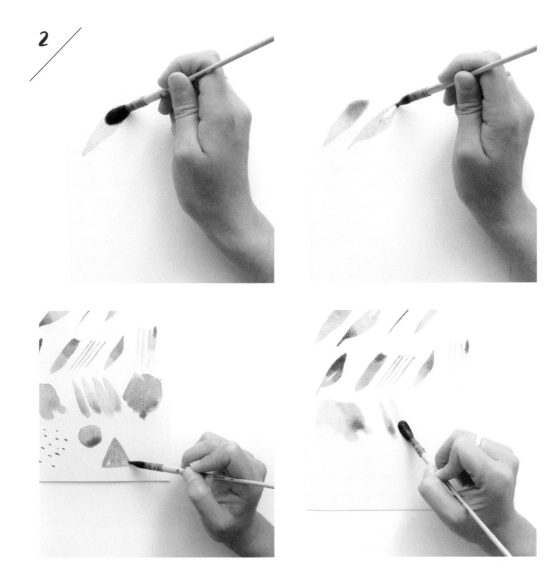

EXERCISE 2: DEXTERITY

Working on your brushstrokes also improves your accuracy and dexterity. For this exercise, explore all the possibilities offered by the brush. Use the tip of the brush and the tuft. Alternate between strokes heading outwards and towards you. Paint geometric shapes, round shapes and thin shapes. Vary how hard you press on the brush. We'll be using these methods in particular for painting leaves later.

Digitizing
YOUR CREATIONS

**YOUR FLORAL CREATIONS CAN BE TRANSFORMED INTO CARDS,
POSTERS AND INVITATIONS USING DIGITAL TECHNOLOGY.
THROUGHOUT THE BOOK, I'LL SHOW YOU LOTS OF IDEAS
FOR USING YOUR CREATIONS IN OTHER WAYS.**

You can also have fun creating digital cutouts of your flowers for overlaying and combining in endless permutations.

There is no need to invest in an expensive professional scanner. If you don't plan on enlarging your creation, set your scanner to 300 dpi, otherwise increase the setting to 600 dpi, which will be large enough for an A3 poster.

If I intend to put my paintings on social media, I don't use my scanner. I simply use the camera on my phone, natural lighting and free apps, such as Snapseed and A Color Story.

If you use photo editing software, here's the simple process I use to retouch my digitized paintings.

• In Settings > Levels, I select the white pipette tool and apply it to the white of the paper to make it stand out. I set the opacity for the layer. If needed, I use a blend mask to recapture the lighter areas that may have been washed out by the levels setting layer.
• In Settings > Hue / Saturation, I slightly increase the saturation level as the scanner tends to have a fading effect on colors.

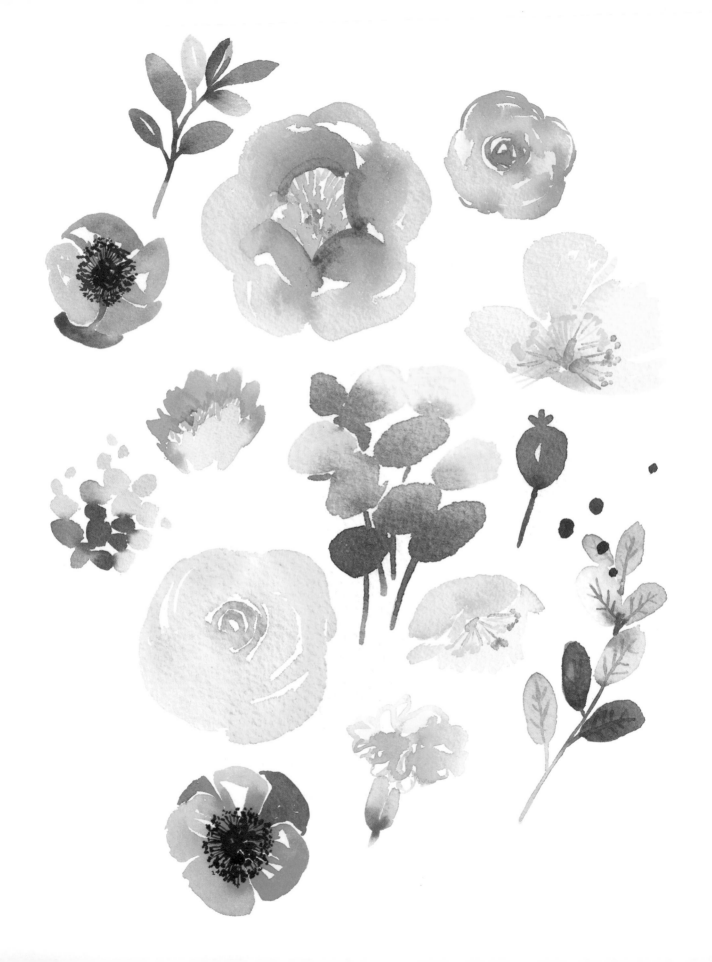

Plant directory

HAVING WORKED ON SOME WATERCOLOR BASICS, LET'S LAUNCH INTO PAINTING FLOWERS AND LEAVES. I'VE COMPILED A LITTLE DIRECTORY BELOW, WITH ELEMENTS INVOLVING A VARIETY OF SHAPES, SIZES AND COLORS. FEEL FREE TO DIP INTO IT WHEN CREATING YOUR COMPOSITIONS TO PRODUCE ENDLESS COMBINATIONS. FOR THE PAINT MIXES REFERRED TO BY NUMBER, SEE MY FAVORITES ON PAGE 28.

YOU'LL SEE THAT THE SUGGESTED TECHNIQUES ARE VERY RELAXED: I'M NOT ATTEMPTING TO REPRODUCE THE PLANTS REALISTICALLY. I'M AIMING FOR BRUSHSTROKES THAT LET ME APPROXIMATE THE SHAPE OF THE FLOWER. NOW IT'S YOUR TURN TO EXPLORE THE POSSIBILITIES WITH YOUR BRUSHWORK AND BRING FLOWERS TO LIFE ON PAPER!

Roses

I SUGGEST THAT YOU PAINT ROSES FROM THREE DIFFERENT ANGLES.
LOOK AT THESE SKETCHES TO GET A BETTER UNDERSTANDING
OF HOW I ARRANGE THE PETALS. TRY CARRYING OUT YOUR
OWN EXPERIMENTS WITH ROSES OF DIFFERENT SPECIES
AND SHAPES – THERE ARE SO MANY TO CHOOSE FROM!

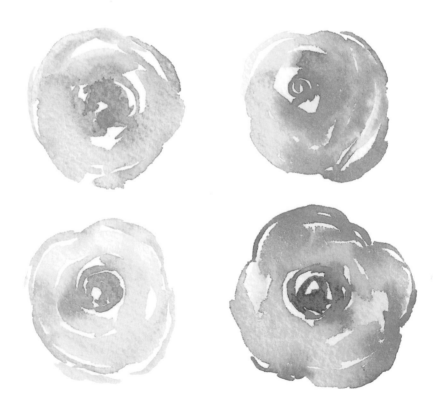

1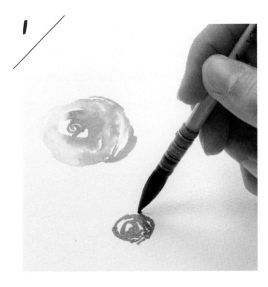

Start with the center of the rose using a well-pigmented mix. Use the tip of the brush to paint little circles.

2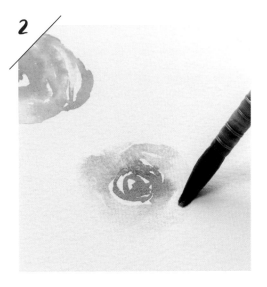

Then rinse your brush well and squeeze it out. Using the tuft of the brush, paint broad petals around the center. Make sure you leave some negative spaces so that the rose appears to reflect the light.

3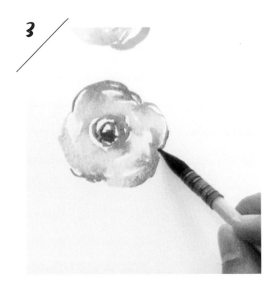

Add details using the tip of the brush and a concentrated mix to suggest outer petals.

1 /

Start from the center with a heavily diluted pink.

2 /

Add more pigment as you move further away from the center. You could also do the opposite to create a different effect.

3 /

The shape of the biggest petals gives the impression of them enveloping the center. Look at the sketch at the top of the page to get a better understanding of how they are arranged.

4 /

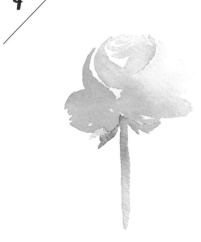

1 /

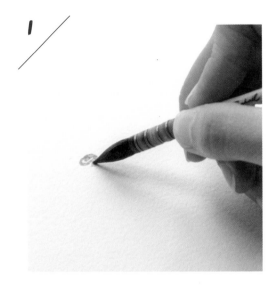

Rosebuds are diamond shaped. Start from the top, using a concentrated mix to paint little circles.

2 /

Shape the right-hand side of the diamond using a more diluted mix.

3 /

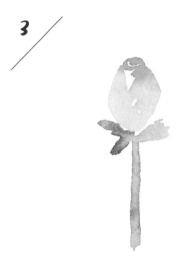

Paint the left-hand side of the diamond, leaving a little negative space in the center to give the bud more shape.

Peonies

LIKE ROSES, IT IS HARD TO CHOOSE A SINGLE WAY OF REPRESENTING
PEONIES. GETTING TO KNOW THE FLOWER AND ITS SPECIFIC
CHARACTERISTICS FROM DIFFERENT ANGLES ADDS INTEREST
TO PAINTINGS, WHICH APPEAR LESS "FLAT". DEPENDING ON
THE PEONY SPECIES AND STAGE OF BLOOMING, THE EXTENT TO
WHICH THE FLOWER HAS OPENED WILL VARY, THE PETALS WILL
BE DIFFERENT WIDTHS AND THE CENTERS DIFFERENT COLORS...
HAVE FUN WITH THIS FASCINATING FLOWER!

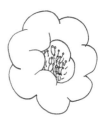

HALF-OPENED PEONY

1

To paint a peony that is still slightly closed up, start with a mix of Carmine Red, Opera Rose and Payne's Gray (No. 9). Paint semicircles curving towards both the inner and outer sections of the flower.

2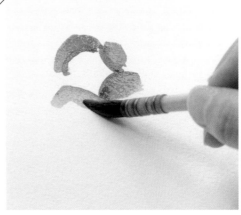

Add to the petals, using a more diluted mix made from Cadmium Yellow and Rose Madder Lake (No. 2).

3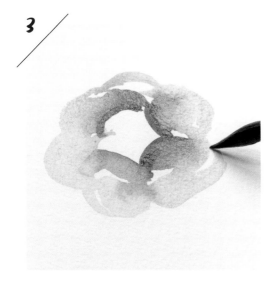

After rinsing your brush, paint arcs to form the outer petals, this time pointing only towards the inside of the flower. Don't forget to leave negative spaces.

4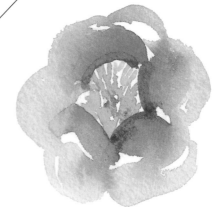

Paint little lines with a fine brush to represent the center of the flower, using a mix of Cadmium Yellow and Quinacridone Gold (No. 8).

1

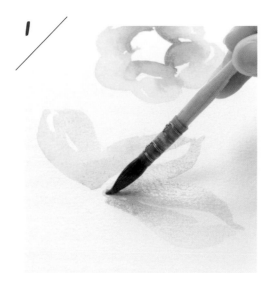

Using a mix that is not very concentrated (No. 2), paint the petals quickly, leaving white spaces.

2

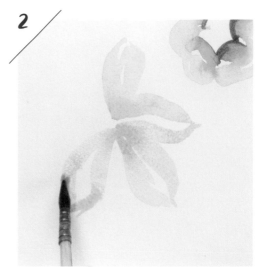

While the flower is still wet, apply concentrated Cadmium Yellow pigments to the center to create a gradation effect.

3

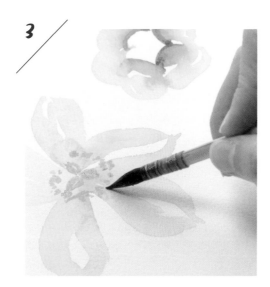

Once everything is dry, paint three big pistils using the same mix (No. 8) as for the closed peony. Create the illusion of lots of stamens, all around, by painting little dots.

4

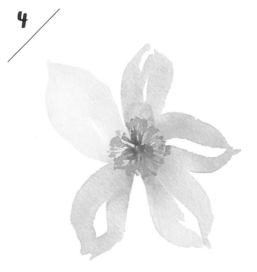

Add thin lines, connected to the pistils, using a fine brush.

1 /

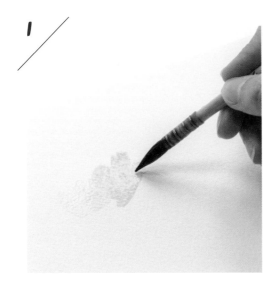

The overall shape of the flower is conical (see sketch). Start by painting the front part of the flower using a diluted mix (No. 2).

2 /

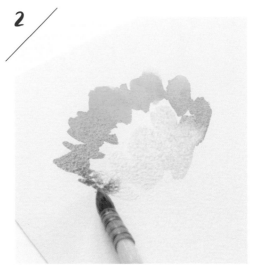

Increasing the concentration (to add dimension), paint the background of the flower (mix Nos. 2 and 9).

3 /

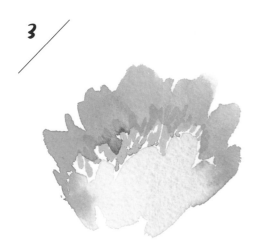

Alter the tint slightly with each brushstroke by adding pigments. Leave a negative space in the center to paint the stamens with the same mix (No. 8).

Carnations

I LOVE PAINTING CARNATIONS AS I FIND THEIR COLORS
AND SHAPES REALLY PRETTY, LIKE LITTLE POMPOMS.

1 /

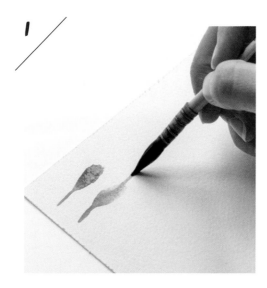

My technique consists of alternating the
amount of pressure on the brush: first,
apply very little pressure for a fine line
and then press hard on the tuft to leave
a wide mark.

2 /

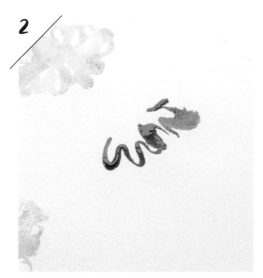

Apply this technique while creating
waves to give shape to your carnation.

3 /

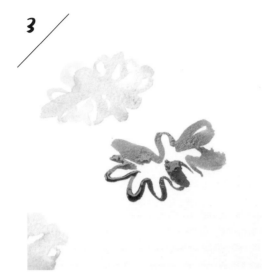

Change color while painting, as carnations often include two colors.

4 /

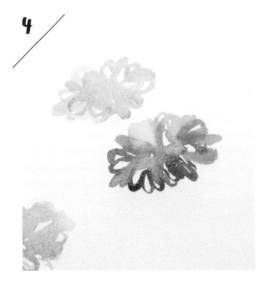

Continue painting with a more diluted mix to generate volume. Be careful not to wash away everything if your painting is too wet. Wait for the carnation to dry in order to go back and add details, continuing to play with the amount of pressure applied to brushstrokes. Don't forget to leave negative spaces, which are essential for bringing the flower to life.

5 /

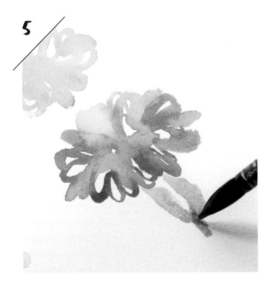

Paint the base of the flower using a yellow-green (mix No. 1) and, before it all dries, add a dot of concentrated Sap Green at the bottom of the stem to create a gradation effect.

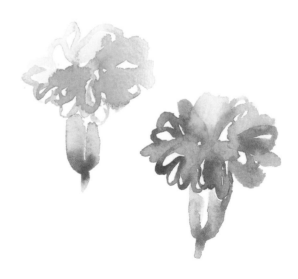

Dahlias

DAHLIAS ARE MAGNIFICENT FLOWERS THAT COME IN MANY
DIFFERENT SHAPES AND VIVID COLORS. ONCE AGAIN, THE
MOVEMENT OF THE BRUSH WILL GIVE LIFE TO THE FLOWER.

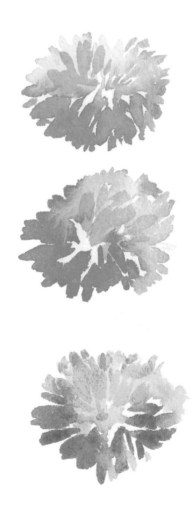

1

Apply an initial color in a quite concentrated form to shape the bottom of the dahlia. Paint little marks pointing towards the center of the dahlia.

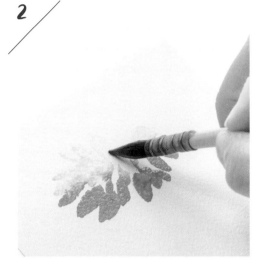

2

Take a second, very diluted color and add marks to the top of the dahlia. Pretty color gradients will start to form.

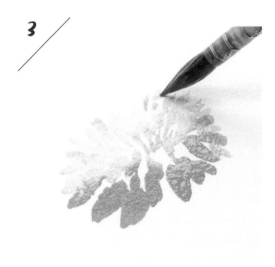

3

Once the flower is almost dry, add slightly finer marks using the second mix in a slightly more concentrated form.

Anemones

ANEMONE PETALS ARE WIDE WITH ROUNDED EDGES. THE FLOWERS OFTEN HAVE TWO LAYERS OF PETALS, WHICH ARE SUGGESTED THROUGH THE USE OF NEGATIVE SPACES AND DIFFERENT COLORS.

1 /

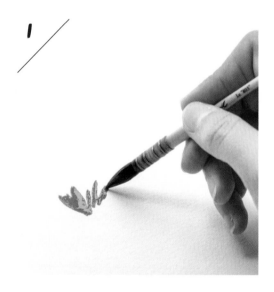

2 /

In order to take care with white spaces, start painting petals using brisk and bold straight strokes.

Add a curved stroke across the top by pressing on the brush head. Wash your brush before painting another petal. It is essential that the flower is not too dark so that the black center creates a lovely contrast. It is the unevenness that gives the flower its natural look.

3 /

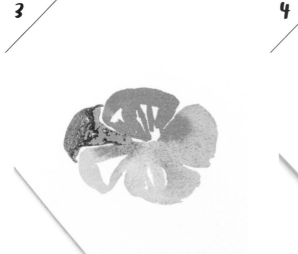

Finish off the petals, slipping some underneath using a darker mix.

4 /

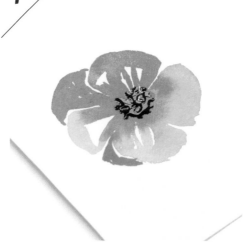

Once everything is dry, paint the center using Payne's Gray. First the round, uneven center and then the stamens.

5 /

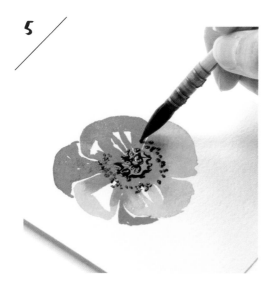

As with the peonies, paint an uneven ring of tiny dots all round the center.

6 /

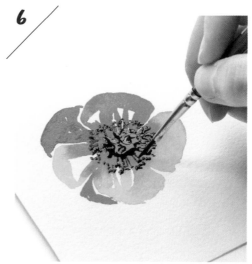

Then connect them together using a fine brush.

Poppies

I PAINT POPPIES FOLLOWING THE SAME PRINCIPLE AS ANEMONES.
THE PETALS ARE MORE JAGGED, AND THE COLORS OF THE FLOWERS
ARE VERY DIFFERENT (ORANGE AND BRIGHT YELLOW, FOR EXAMPLE),
AS ARE THE CENTERS (YELLOW-GREEN INSTEAD OF BLACK).

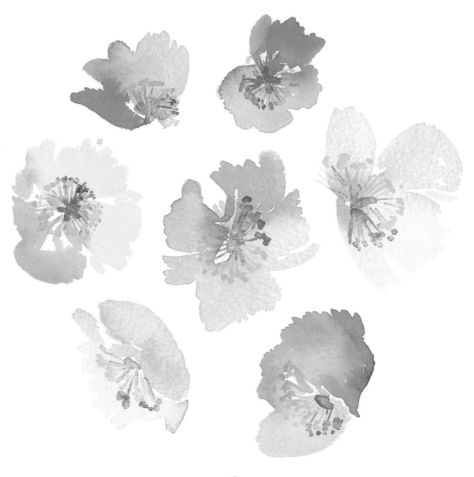

1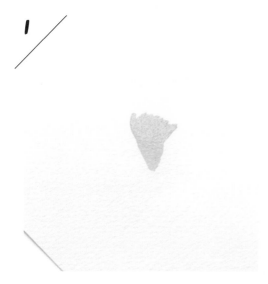

In the same way as for anemones, paint the petals one by one, this time creating uneven edges.

2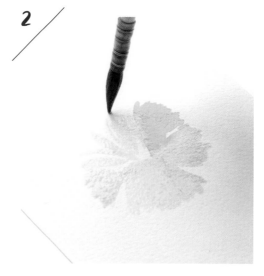

Change color and pigment strength for each petal.

3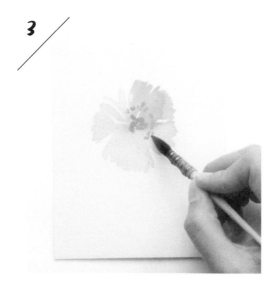

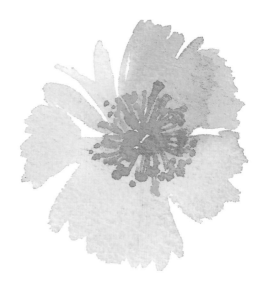

Add the center using a mix of Lemon Yellow and Quinacridone Gold, as well as a little Sap Green for the pistil. Try to vary the viewing angles and colors to add interest (see examples opposite).

Foliage

USE THIS FOLIAGE DIRECTORY FOR INSPIRATION WHEN STRUCTURING YOUR FLORAL COMPOSITIONS. I USE LEAVES WITH SIMPLE SHAPES. I'M NOT ATTEMPTING TO REPRODUCE THE FOLIAGE TO MATCH A SPECIFIC FLOWER. THIS SIMPLIFIES THE CREATIVE PROCESS, LETTING ME PAINT MORE FREELY AND WITH GREATER SPONTANEITY. WHAT MATTERS IS HAVING FOLIAGE IN VERY VARIED SHAPES TO ADD INTEREST TO COMPOSITIONS.

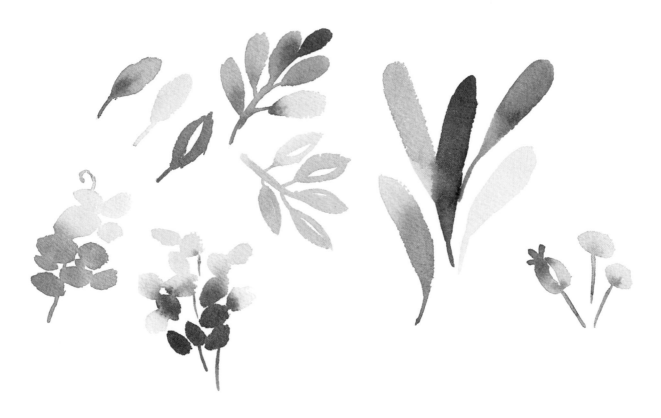

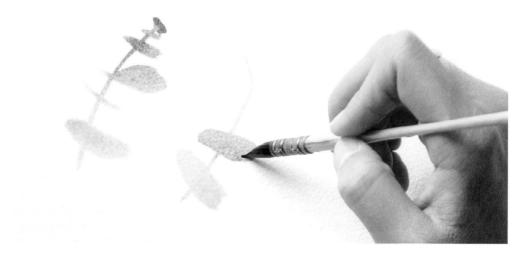

EUCALYPTUS

Eucalyptus is a lot of fun to paint. Create the stem using a very diluted mix. Then paint the leaves at different angles, varying the color and size. Use the technique shown on page 40 to create color gradients.

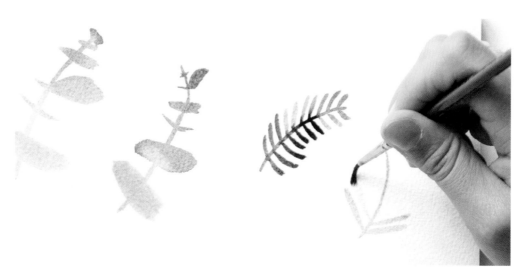

PALM LEAF

Use a fine brush to paint this leaf. Paint the central stem and then add the little leaves around, painting from the inner edge outwards.

SIMPLE ROUND LEAF

I use this type of simple round leaf a lot. Paint the stem, using the tip of the brush and then press on the tuft, working outwards. A single brushstroke and the leaf appears! I love adding more concentrated pigments to the stem to create a color gradient.

SIMPLE POINTED LEAF

For this leaf use the tip of the brush, this time working from the outer edge inwards and finishing with the stem. Press down hard when painting the body of the leaf. You can leave a carefully shaped white area to suggest light.

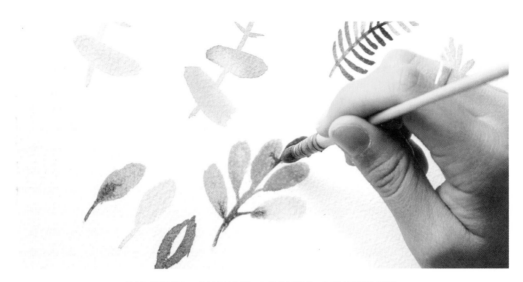

PUTTING SIMPLE LEAVES TOGETHER

You can assemble your individual leaves, whether round or pointed, into sets by means of little stems. Try not to make things symmetrical or too even, so that the leaves retain a natural look. Play with leaf size, especially for the smallest ones at the tip of the stem. Also try experimenting with colors and tonal values.

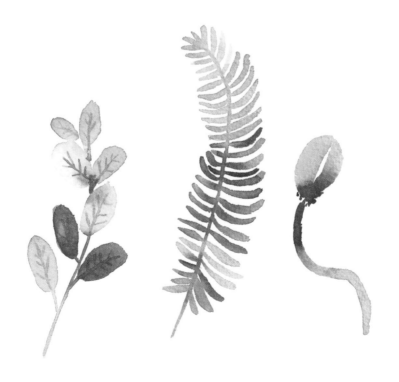

LARGE ROUND LEAF

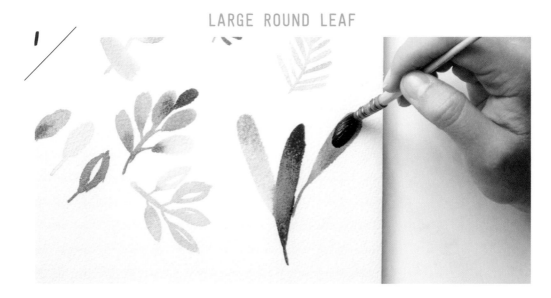

I use the same brush technique as for the simple round leaf to paint this large leaf. Make sure that you load your brush with plenty of my mix if you want to paint larger shapes. A single brushstroke and the leaf appears! I love adding more concentrated pigments to the stem to create a color gradient.

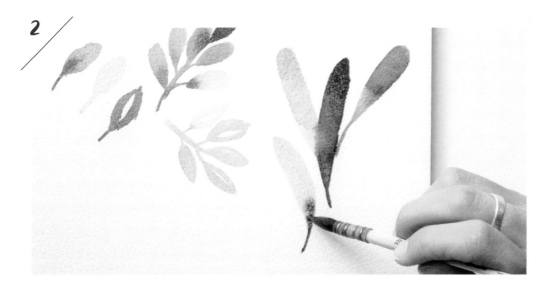

Because of their length, these leaves create a lovely contrast and can also lend a sense of movement (see Poppy streamer on page 146).

1

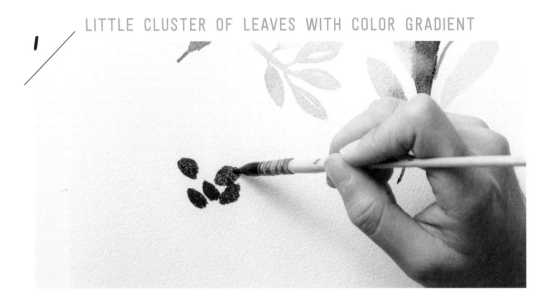

I use these little leaves when I need to fill empty spaces or have overlapping layers as, on their own, they are less interesting. To paint them, use a heavily concentrated mix (e.g. No. 3 or 4) and paint round shapes quite close together.

2

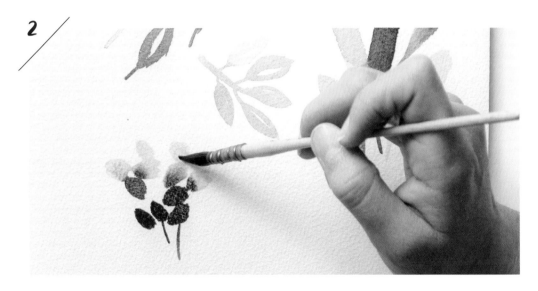

Paint stems and then rinse your brush well. Continue with round shapes, letting them touch to create lovely color gradients.

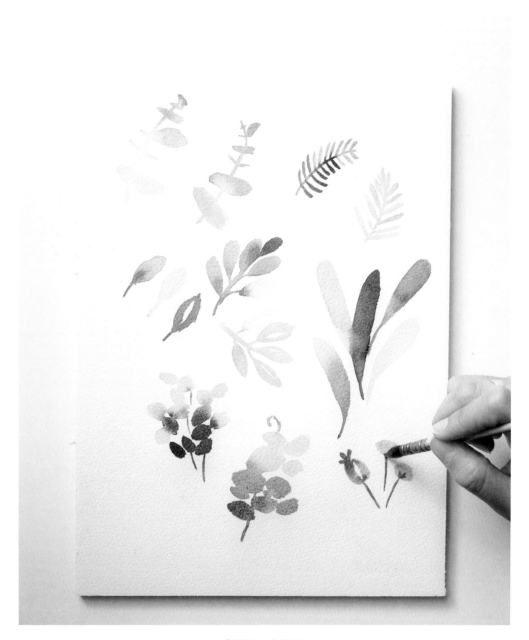

SEED PODS

In my compositions I often add seed pods, round shapes at the end of a stem (see Foliage frame on page 106). Once again, try playing with color gradients by adding more concentrated pigments to a fairly light shape before it's dry.

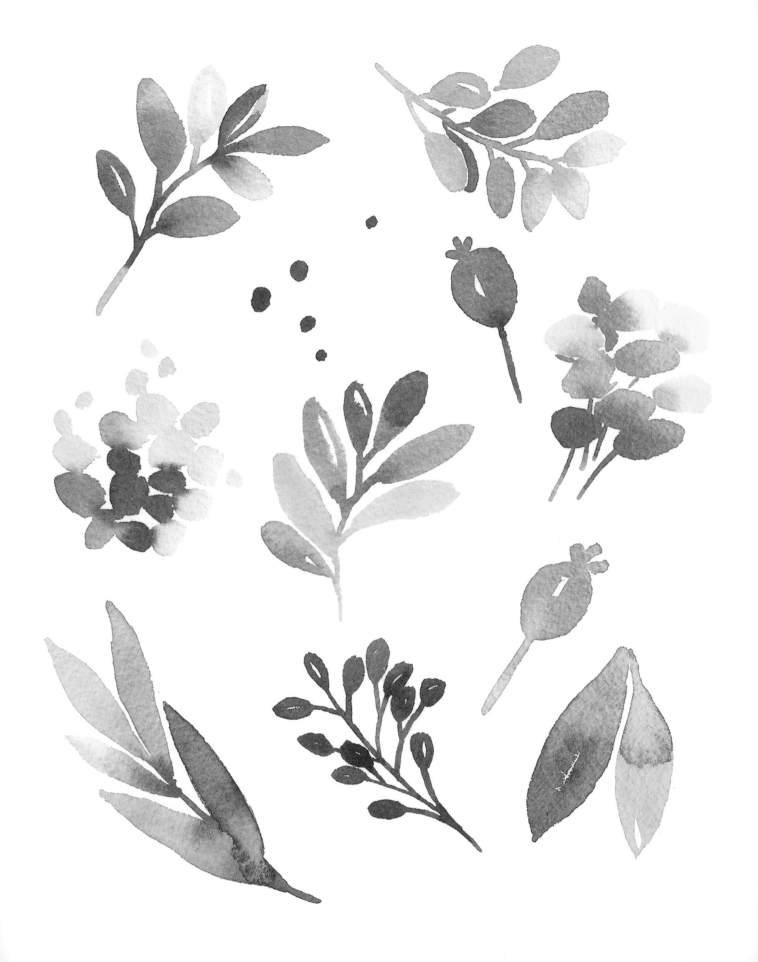

Detail and texture

AS IN A REAL BOUQUET OF FLOWERS, WE'RE NOW GOING TO ADD
DETAIL AND TEXTURE, WITH THE FOLLOWING DIFFERENT COLORFUL
ELEMENTS PLAYING THE ROLE OF SECONDARY FLOWERS.

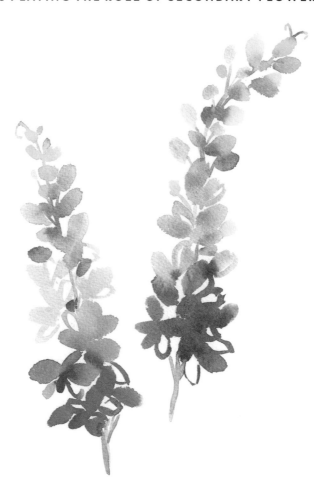

THE DELPHINIUM, WITH ITS
LOVELY CLUSTER OF COLORFUL
FLOWERS, CAN BE THE MAIN
ELEMENT IN A BOUQUET.
I LOVE USING ITS LARGE
SHAPE TO FILL EMPTY SPACES
IN THE BACKGROUND OF A
COMPOSITION (SEE COLORFUL
BOUQUET ON PAGE 126).

1

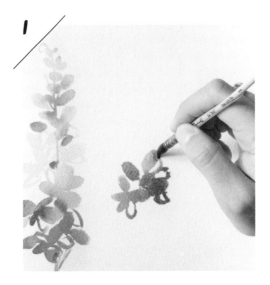

Start by painting the flowers at the bottom. Alternate between filled-in and hollow shapes, using a quite concentrated mix, in this case it's Deep Cobalt Blue mixed with a little Opera Rose (No. 15).

2

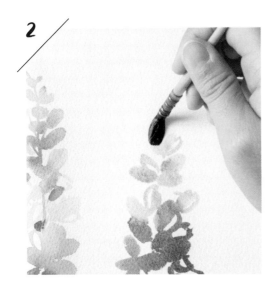

Dilute your mix and continue with more flowers, spaced increasingly further apart as you move up the stem.

3

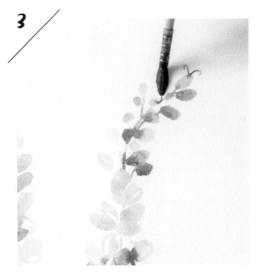

When you get to the top, use a yellow-green mix (No. 1) for the buds. Work fast so that lovely color gradients form while the paint is wet. Don't forget the stems! You can also start with the buds and finish with the flowers – it's up to you.

HORTENSIA

A few little hortensia (hydrangea) flowers in simple shapes can easily finish off a creation (see Flower ball on page 86).

1

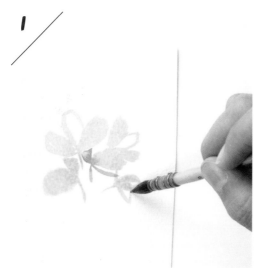

Paint several flowers together, using the same technique as for the delphinium. Vary the pigments to create different tints.

2

You can accentuate certain areas by painting the contours and stems in a more concentrated mix.

DECORATIVE CLUSTERS

1

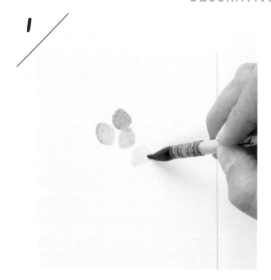

I adore adding little clusters to my creations. You just need to paint several colorful ball shapes, taking care not to distribute them too evenly so you get a natural effect.

2

Add stems using a fine brush once the rest is dry.

ASTILBE

The astilbe has feathery-looking diaphanous flowers, shaped like darts. They are ideal for adding to a composition to lend movement and body.

1

Using a fine brush and a mix of Deep Cobalt Blue and Opera Rose (No. 15), tap the paper with the brush to recreate the gossamer-like shape of the flower.

2

Rinse and wipe your brush, then continue to tap, working your way up to form the tip of the flower. The fact that the brush is quite dry will leave more interesting marks. Then add the stem – here I used Indigo Blue mixed with Sepia (No. 3).

Compositions

LEARNING TO PAINT FLOWERS AND FOLIAGE IS AN EXCELLENT START. THE NEXT STAGE IS LEARNING TO ARRANGE THEM TOGETHER TO CREATE A HARMONIOUS PICTURE.

In order to do that, we're going to review seven types of floral compositions. For each composition, I've produced a step-by-step example that you can follow in the next chapter. Don't be afraid to try out other compositions of your own invention too. There are lots of possible combinations, just using these seven compositions and all the flowers shown.

BOUQUET

The bouquet is the most common composition for painting flowers. And yet it's not the easiest. In order for it to succeed, pay attention to creating the illusion of stems and add depth to the plants through the use of overlapping layers. Arrange the different floral elements at varying levels so that the bouquet looks more natural.

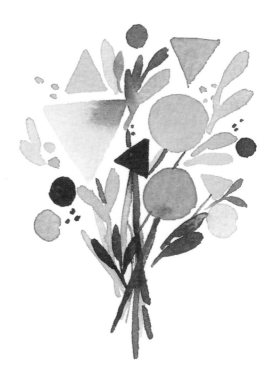

FLOWER BALL

The ball-shaped composition removes the difficulty of the stems that you have in a bouquet. Concentrate solely on the flowers and leaves. Use little elements and leaves to fill in the ball and give it a nice round shape.

PATTERN

A pattern composition consists of spacing out different flowers and leaves on a sheet of paper in a harmonious manner. Varying the viewing angles of the elements and letting them appear to extend beyond the work space adds interest to the composition.

FRAME

I really love this elegant composition, created using masking tape. You just need to paint the floral elements on top and then carefully peel off the tape once everything is dry. You can create various shapes for the frame, for example by using masking fluid.

FRIEZE

Arranging floral elements as a frieze allows you to make pretty cards and invitations once you've scanned in your creation. By playing with movement and using a clever mixture of flowers and leaves, the frieze gains in complexity and interest.

CIRCLET

I find the circlet-shaped floral composition very elegant. Whether it is quite lightly filled or densely packed, the circlet is ideal for decorating a card or poster. Play with the direction in which the flowers and leaves point to make it more natural.

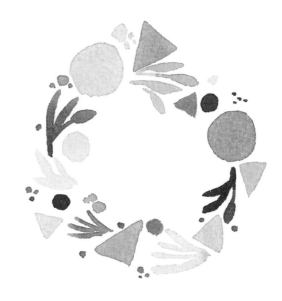

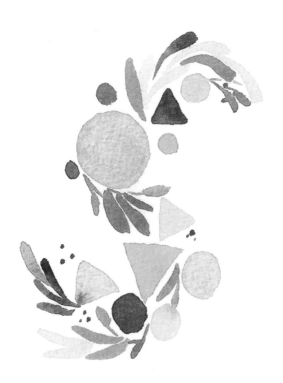

STREAMER

The streamer or "S"-shaped floral composition is not the easiest. I love the harmonious, original result it creates. Try it! The key is to play with the movement of the flowers and leaves, heading in opposite directions at the ends of the "S". You can turn your paper around to make things easier.

Get inspiration for your floral compositions from the following suggestions.

Choose:
• one or two main flowers,
• one or two secondary flowers,
• two or three types of foliage.

Don't forget to vary the size, shape and color of the elements to get a lovely contrast (see page 44).

Flower compositions

IN THIS CHAPTER, WE'RE GOING TO PAINT SEVEN DIFFERENT FLOWER COMPOSTIONS, STEP-BY-STEP, HIGHLIGHTING ONE OR TWO FLOWERS FROM THE PLANT DIRECTORY. FEEL FREE TO EXPERIMENT WITH YOUR OWN COMBINATIONS TOO!

YOU CAN REFER BACK TO PAGES 21 AND 28 FOR YOUR CHOICE OF COLORS. FOR GREATER FLUIDITY, TRY DIFFERENT MIXES FOR YOURSELF, USING THE COLORS I CHOSE FOR INSPIRATION.

THESE PAINTINGS CAN BE FRAMED, TURNED INTO CARDS OR INVITATIONS, OR EVEN USED AS COMPUTER SCREEN WALLPAPER. HAVE FUN EXPERIMENTING, USING THE IDEAS I'VE SHOWN IN EACH PROJECT FOR INSPIRATION.

Flower ball

THE BALL-SHAPED FLORAL COMPOSITION IS HARMONIOUS AND
FAIRLY EASY TO DO. MAKE SURE YOU LEAVE ENOUGH SPACE
BETWEEN THE DIFFERENT ELEMENTS TO INSERT FOLIAGE,
WHICH WILL COMPLETE THE WHOLE COMPOSITION.

The plants

The main colors

Mix No. 1

Mix No. 2

Mix No. 3

Mix No. 4

Mix No. 8

Mix No. 9

Mix No. 10

Mix No. 11

Mix No. 12

Mix No. 14

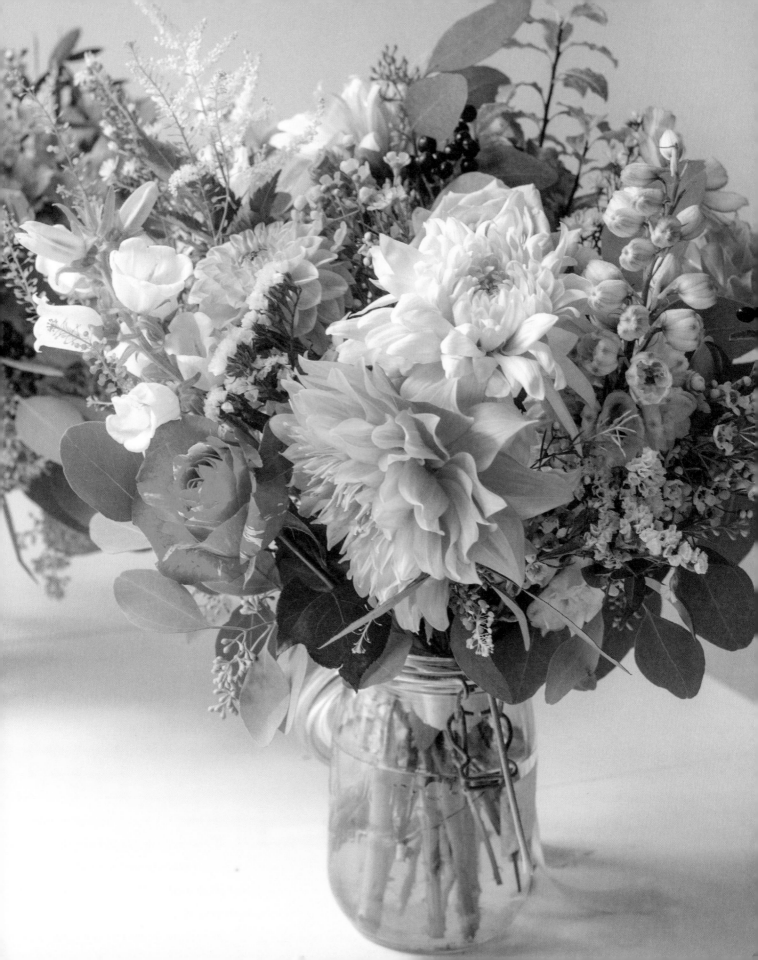

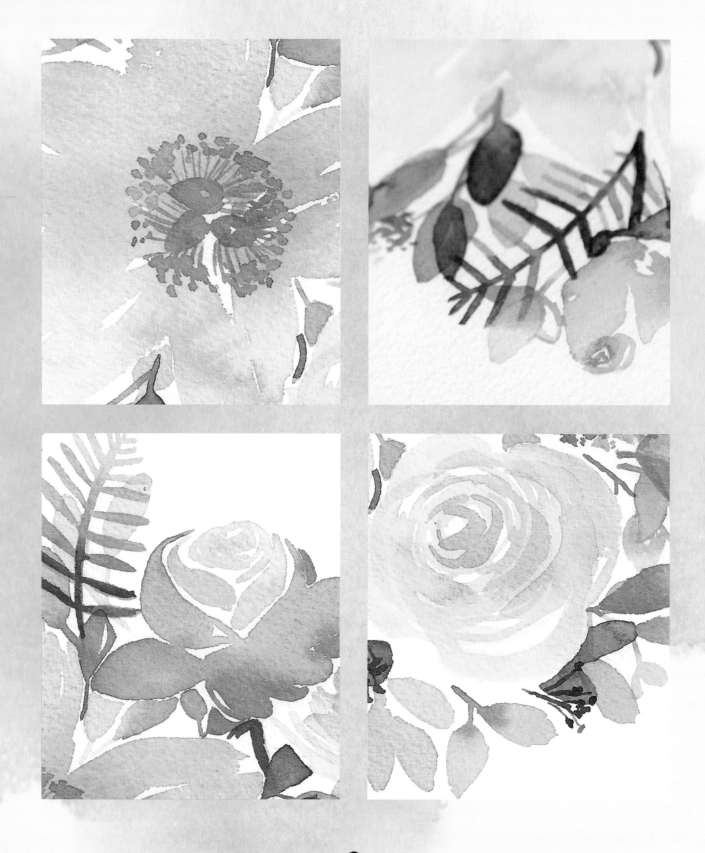

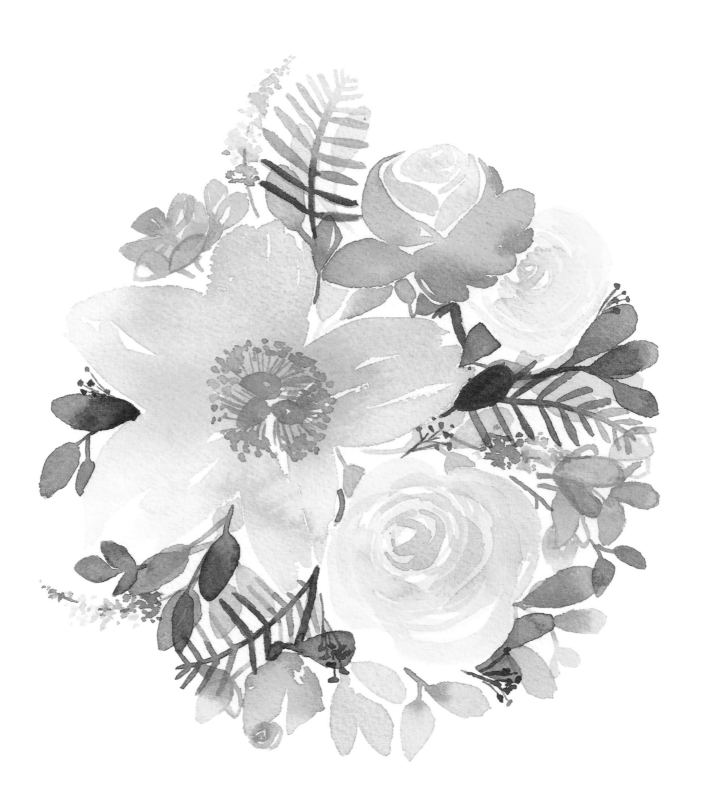

1

The flower ball structure is made up of three roses, a rosebud and a peony. Start with the first rose, seen from the side, using mix No. 2.

2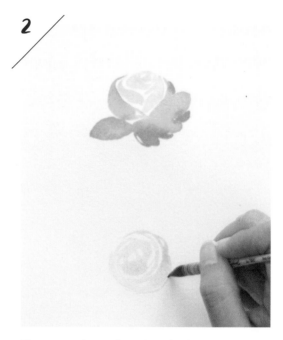

The second rose is painted using mix No. 14 and viewed from a different angle (from the front).

3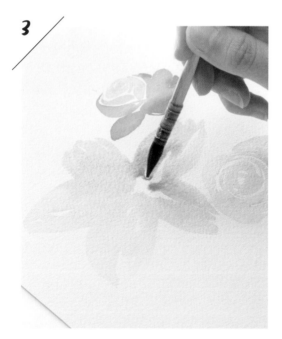

When painting the large peony, think about the ball shape. You can use four pencil dots to get a better idea of the contour of the bowl.

4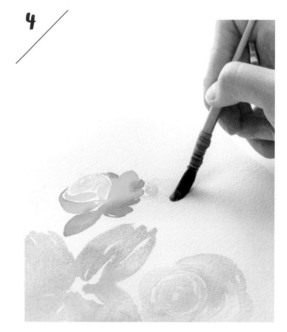

I generally try to paint an uneven number of each of my chosen flowers. The final rose, painted from the front using mix No. 10, is half-hidden behind the first.

5 /

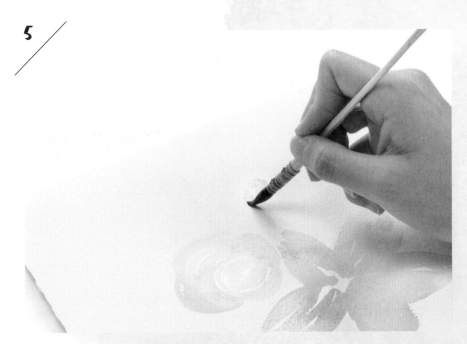

To finish off the main flowers, paint a little rosebud. I turn my paper to paint, which lets me arrange the elements better around the bowl.

6 /

Now let's paint the first simple round leaves using a blue-green mix (No. 11). I have arranged them around the outside of the bowl.

7

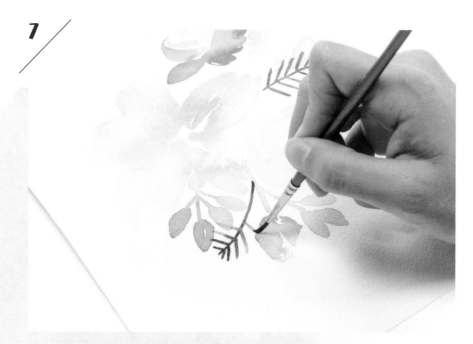

To add variety, paint slender, dark palm leaves (mix No. 3) that provide a strong contrast to the first set of leaves. Arrange them in the same, clockwise direction.

8

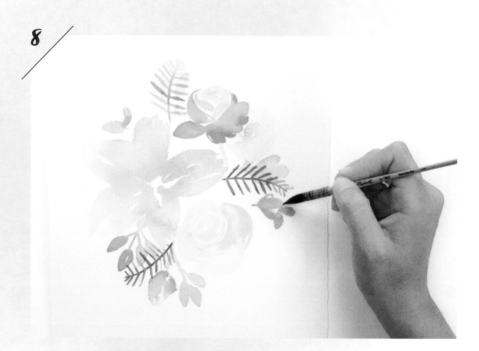

Now turn to the secondary flowers. Add hortensia flowers (mix No. 12) to adorn the outer edge of the bowl and add interest to the composition.

9

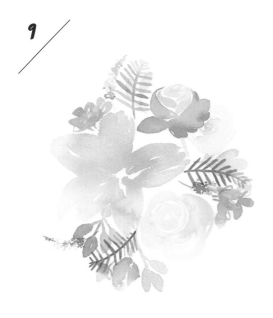

Paint several astilbe flowers, also following a clockwise direction (mix No. 9).

10

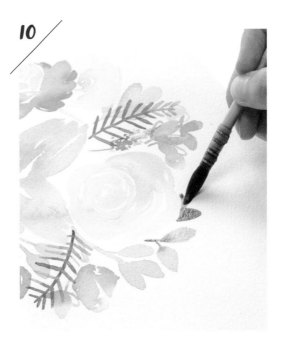

Now that all the main and secondary elements have been painted, add simple leaves in a more intense color (mix Nos. 1, 3 and 4). Feel free to paint them half-hidden under the flowers.

11

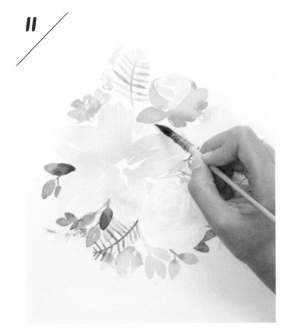

Don't forget to paint simple leaves in the center of the bowl, in between the main flowers. Alter the tonal values: use lighter and darker tones by varying the amount of water used.

12

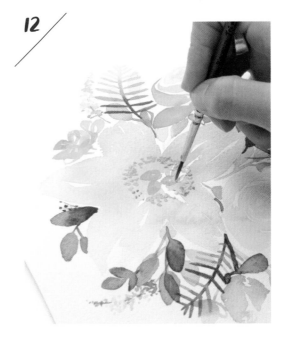

Lastly, apply the finishing touch to your composition by painting the center of the large peony (mix No. 8).

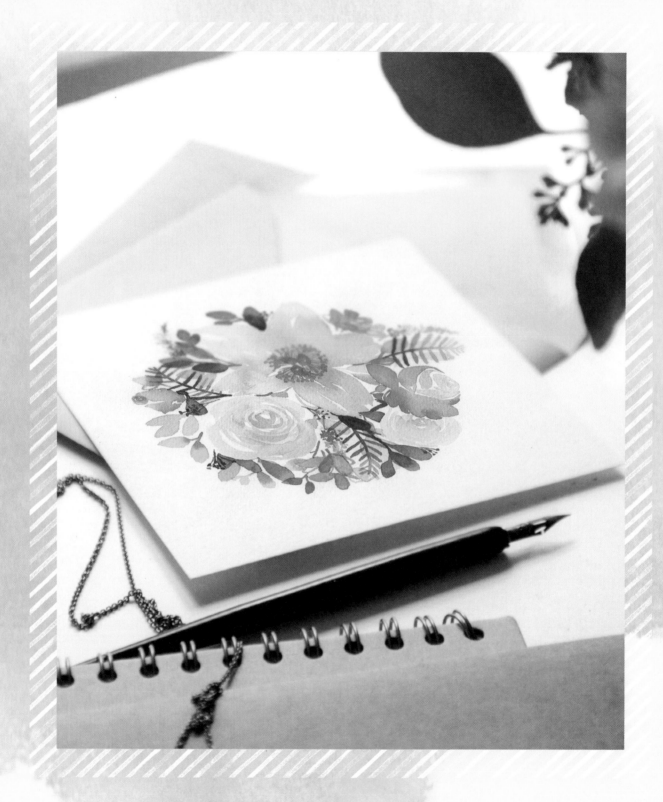

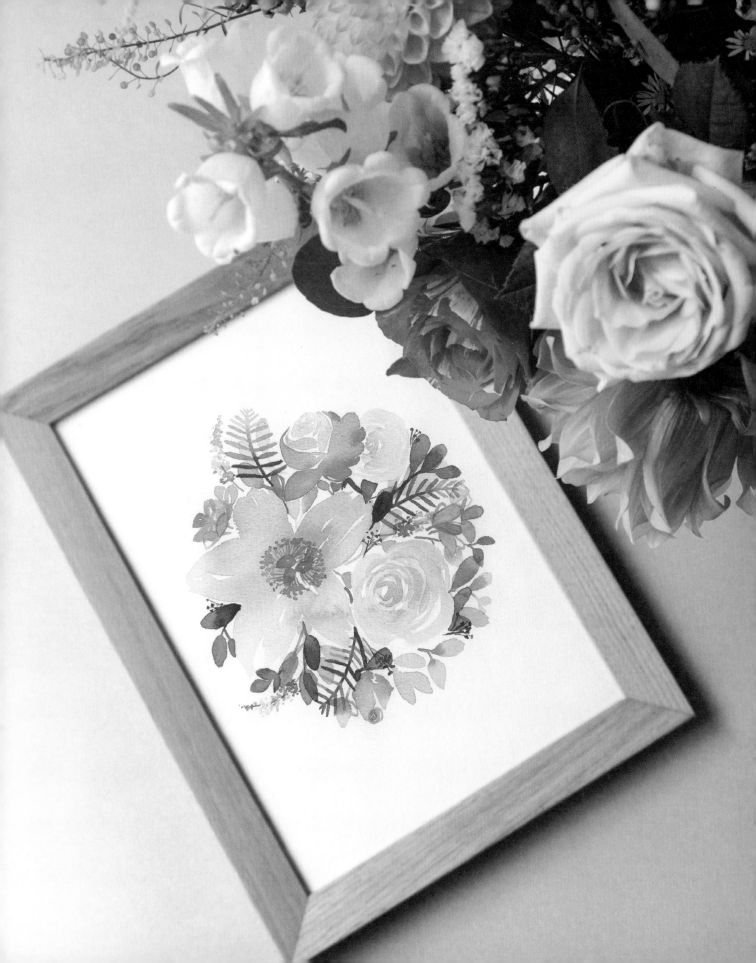

Carnation frieze

AS THE FRIEZE HAS THE SIMPLEST SHAPE, WE'RE GOING TO GIVE DIRECTION TO THE FLOWERS AND FOLIAGE TO CREATE MOVEMENT. THE SMALL, COLORFUL ELEMENTS WILL ADD TO THE FRIEZE TO KEEP ITS LINEAR LOOK.

The plants

Carnations page 60

Sets of simple pointed leaves page 70

Decorative clusters page 78

The main colors

Mix No. 1

Mix No. 2

Mix No. 3

Mix No. 5

Mix No. 6

Mix No. 11

Mix No. 14

Mix No. 15

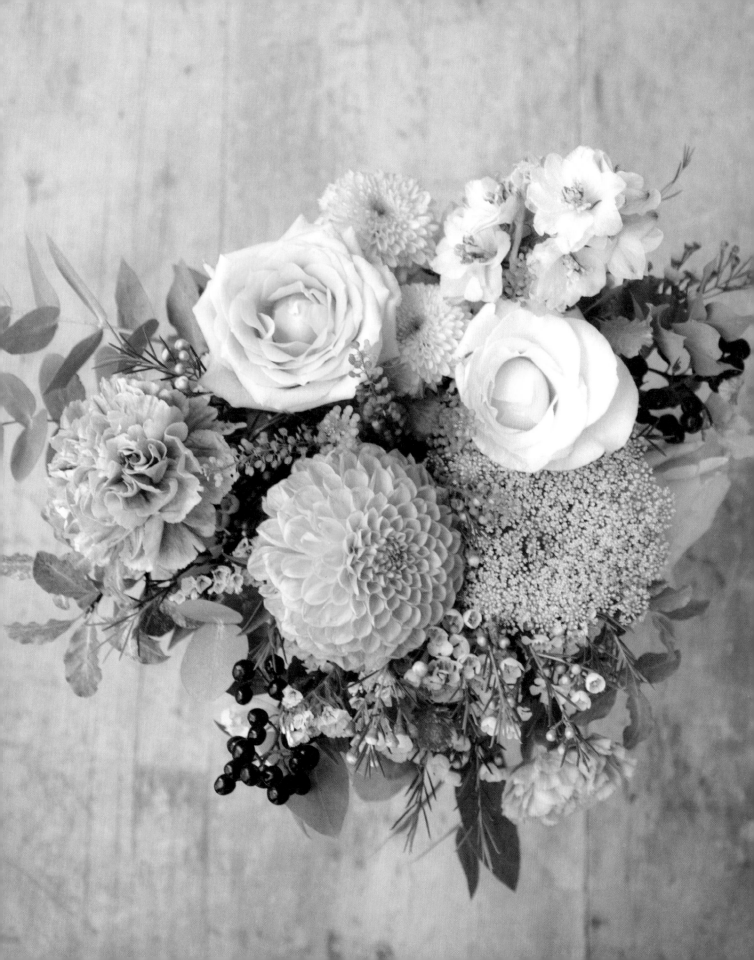

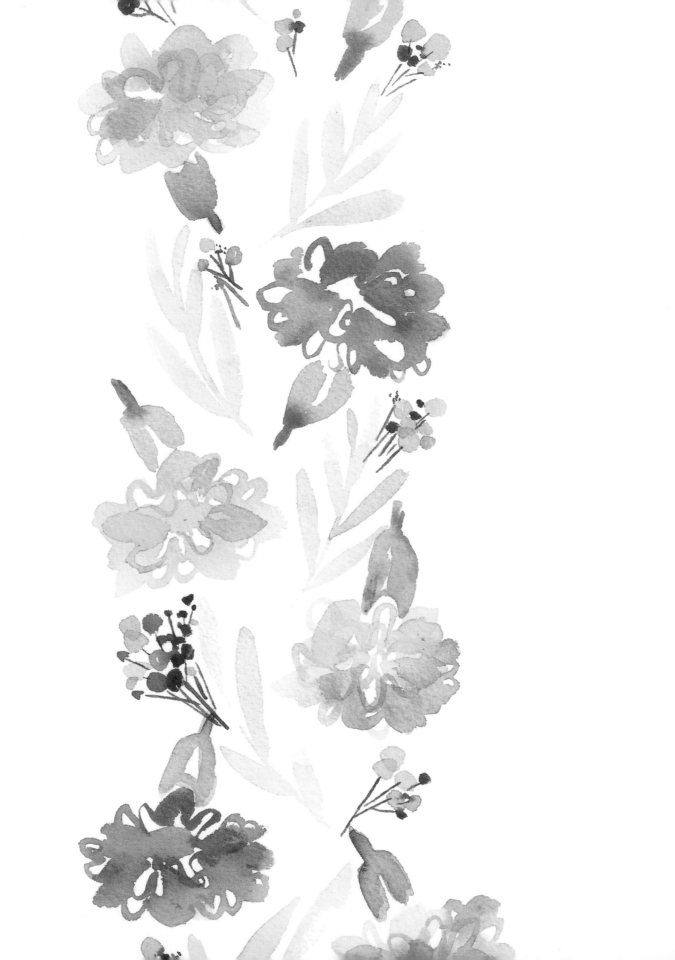

1

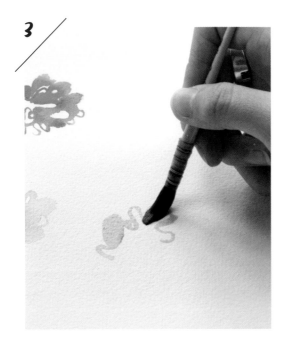

Start the frieze with the flowers, which will give structure to the composition. Paint the colorful part of the carnations first (mix Nos. 5 and 15 for the first carnation).

2

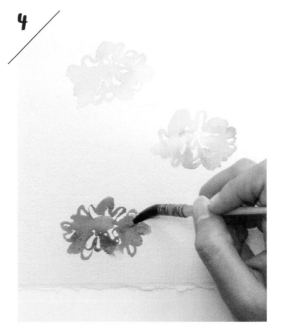

The flowers are evenly spaced. I could have chosen to paint them very close together; that's something to try on another frieze in the future. The colors for the second flower are mix Nos. 2 and 14.

3

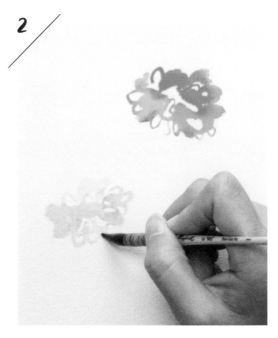

Take care not to position two carnations of the same color next to each other. In order to do that, alternate between three types of carnation: red and magenta, pink and beige, and yellow and violet (Quinacridone Gold and mix No. 6).

4

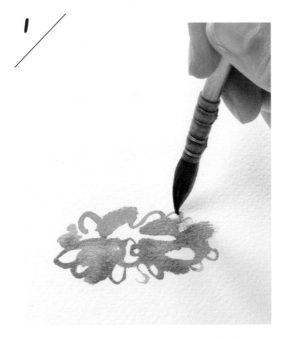

The flowers are angled in different directions to create movement. Don't over-emphasize the angle to keep a sense of harmony.

5

The frieze must give the impression of being never-ending. To achieve that, place a sheet of rough paper under your board and paint the carnations at the bottom and top of the frieze so that they overlap the two sheets.

6

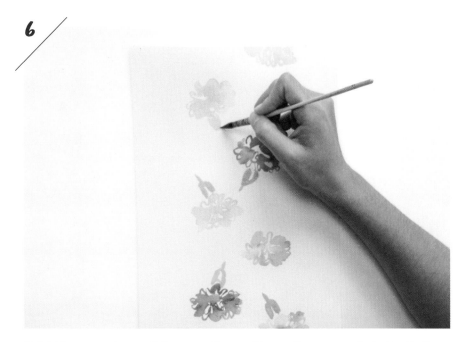

Paint the green base of the carnations with a yellow-green (mix No. 1). It should follow the angle of the flowers, in an alternating direction.

7

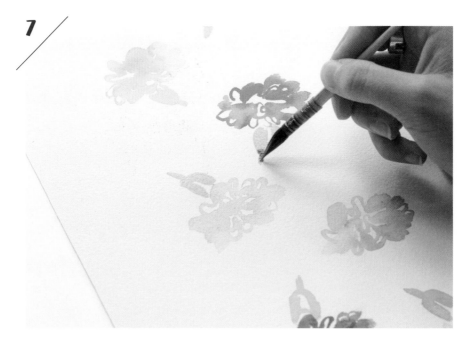

Before the color dries, add some Sap Green to create a gradation effect for the stem.

8

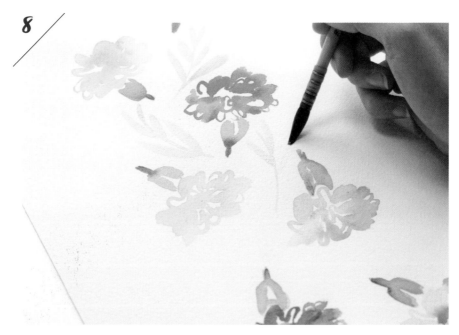

Add slender, pointed leaves to the frieze using diluted mix No. 11. This very light blue highlights the flowers.

9

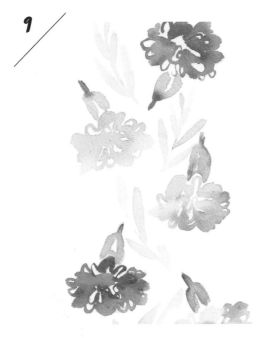

The leaves go in the same direction, like a river carrying the flowers along in the current.

10

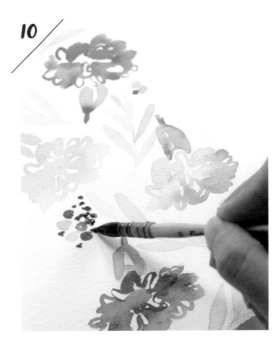

Arrange clusters of balls of different colors and sizes. This stage lets you balance the composition and fill in the outer border of the frieze to make it straighter.

11

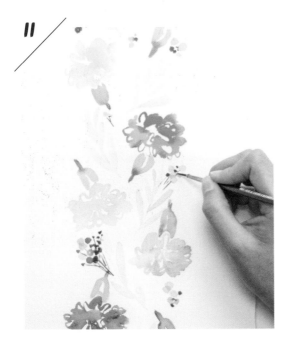

Paint the stems of the little clusters of balls with a No. 3 mix and a fine brush.

12

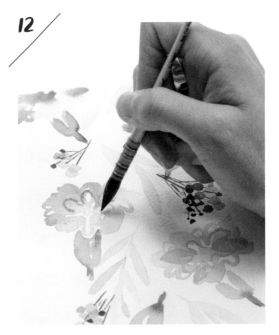

To finish off, add details to the dry carnations, using slightly darker mixes than for the lower layers.

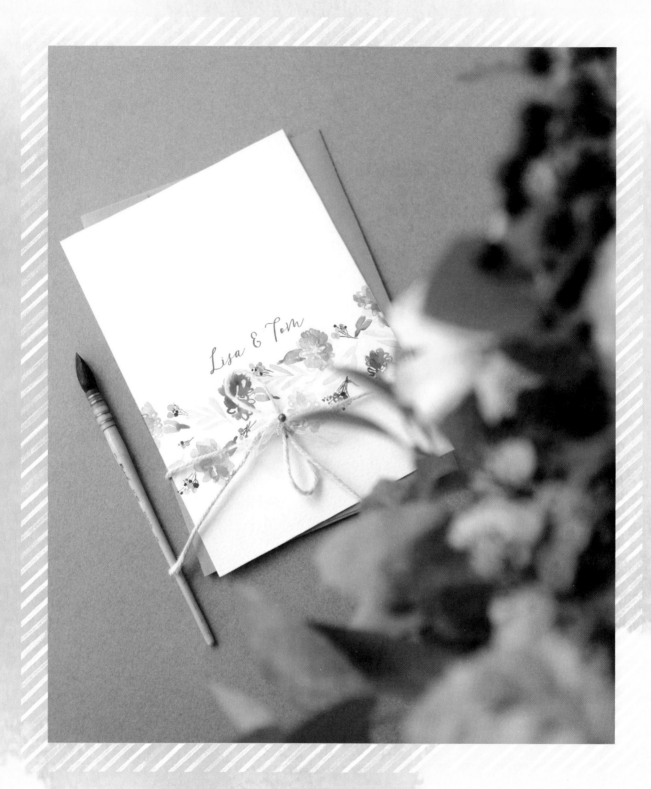

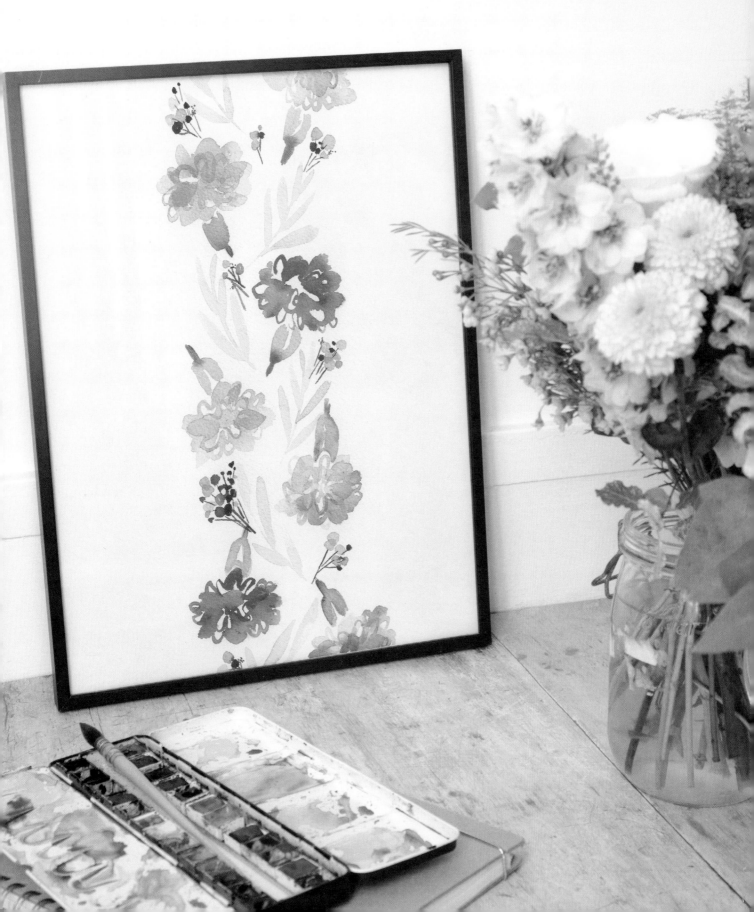

Foliage frame

FOLIAGE ON ITS OWN IS ENOUGH TO CREATE A PRETTY COMPOSITION. LETTING THE LEAVES OVERLAP EACH OTHER GIVES THE EFFECT OF DENSITY AND MOVEMENT. THE LEAVES' DISORDERLY APPEARANCE IS BALANCED BY THE SHARPNESS OF THE CENTRAL SQUARE THAT CAN BE USED FOR INSERTING A SIMPLE MESSAGE.

The plants

Foliage and seed pods
page 68

The main colors

Mix No. 1

Mix No. 3

Mix No. 11

Mix No. 13

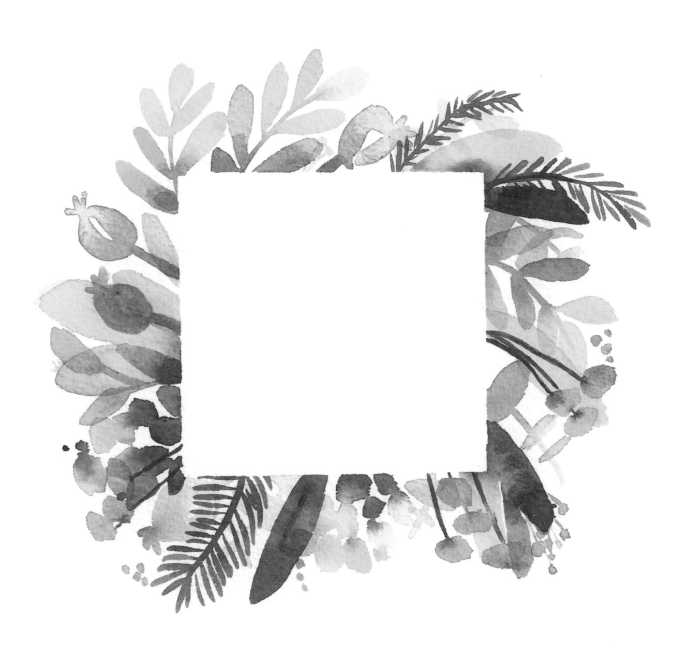

1 /

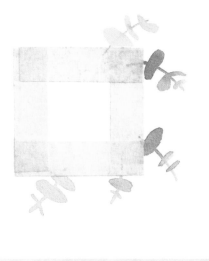

Cut four strips of masking tape. Stick them to your skin and peel them off again several times, so that the tape won't damage the paper. Make a square shape in the center of the sheet. Paint several eucalyptus branches in light blue (mix No. 11).

2 /

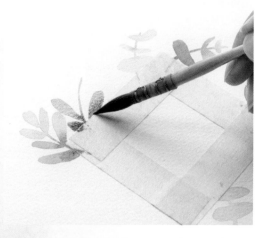

In order to make the frame really stand out, ensure that you paint some of the foliage onto the tape. Add more concentrated pigments near the frame to emphasize it (mix Nos. 1 and 13 used here).

3 /

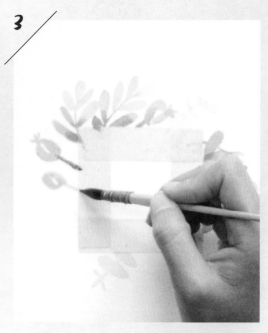

Then add seed pods (Quinacridone Gold). Try to distribute the various elements in an irregular way, as that will make your composition more interesting. You could group the seed pods together, for example.

4 /

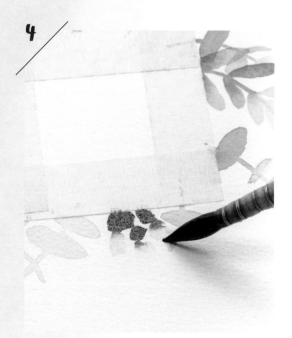

Now we're going to paint clusters of leaves. Lay down a highly concentrated color (mix No. 3) near the frame, then rinse your brush well to paint leaves further away from the frame, creating a color gradient.

5 /

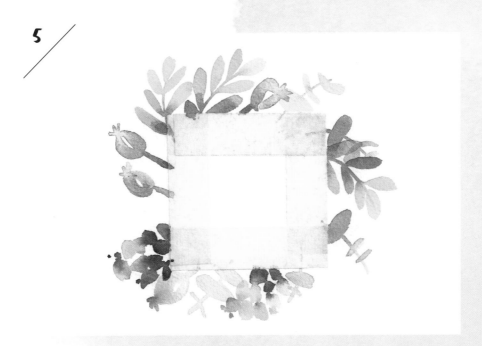

Try to create movement. I've chosen to curve the leaves in a clockwise direction.

6 /

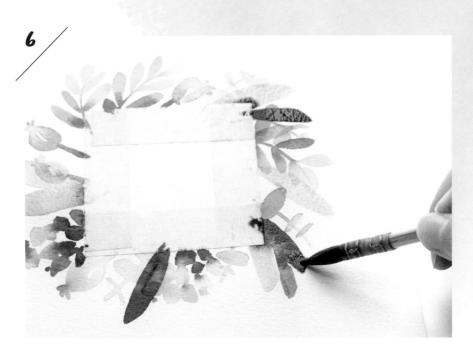

Once everything is dry, we're going to put some long, rounded leaves in place. Some will be very light, letting the previous layers show through. Others will be almost opaque, adding contrast to the composition.

7

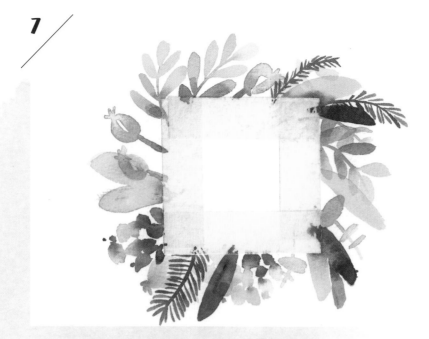

Add palm-like leaves using a blue-green mix (No. 3). Feel free to play with the sizes of the elements.

8

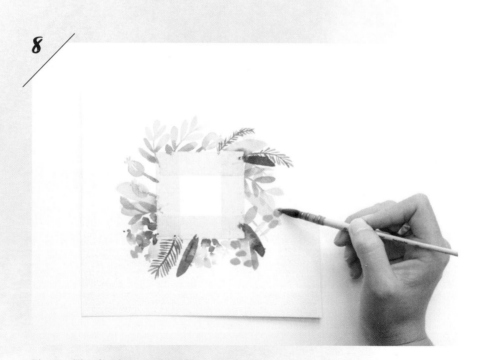

Then add a final type of leaf: round with a long, slender stem (mix No. 1). You have to know when to stop, before the composition starts to look too densely packed; that's not always easy.

9

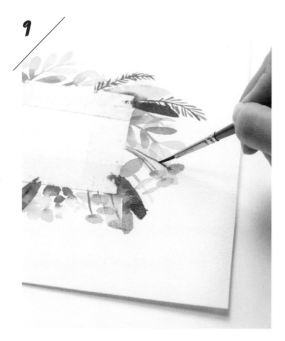

Paint the stems of these leaves using a fine brush and a more concentrated green (mix No. 13).

10

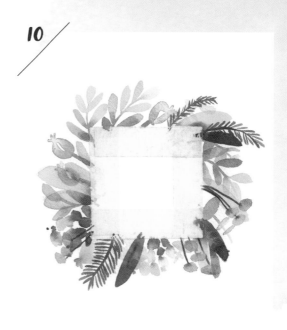

Complete with simple leaves, playing with transparency to cover the frame evenly.

11

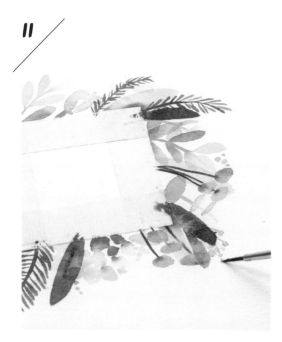

Add small yellow dots as a little reminder of the seed pods.

12

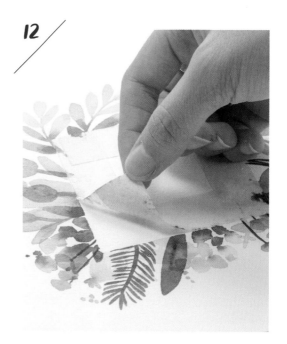

Wait for everything to dry before peeling off the masking tape carefully. You can write a message in the frame if you want.

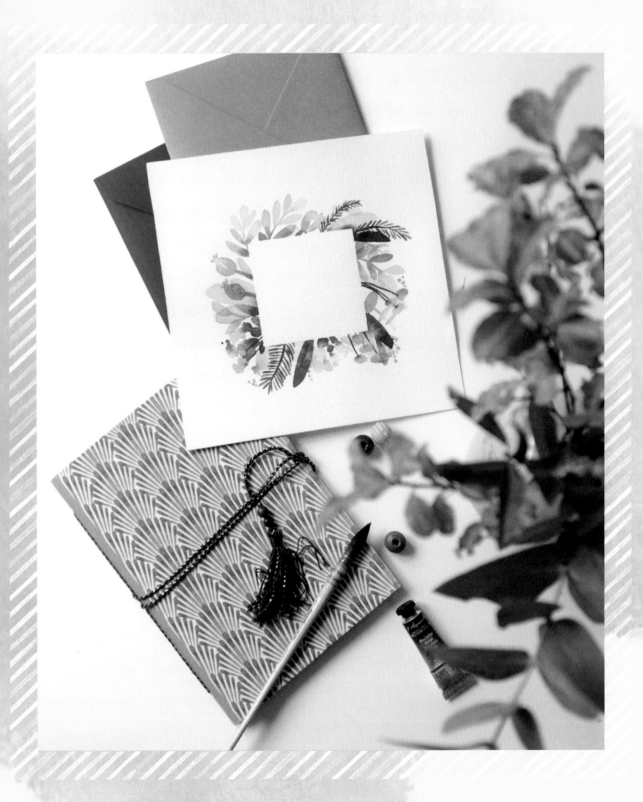

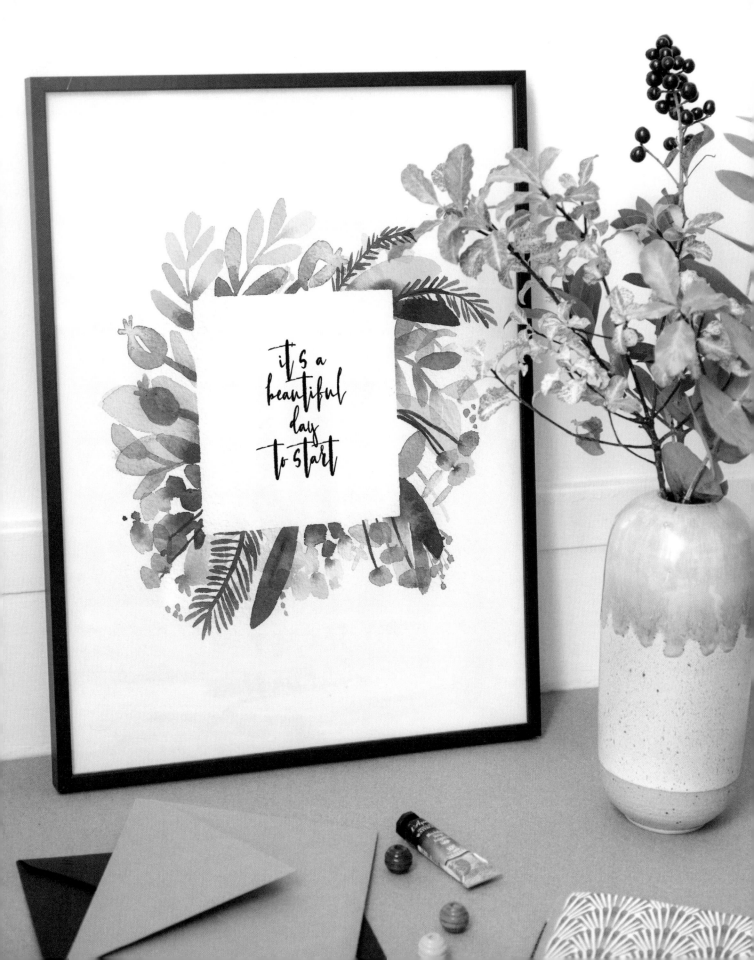

it's a
beautiful
day
to start

Violet circlet

THE CIRCLET IS AN ELEGANT COMPOSITION. THE DIFFICULTY LIES IN CREATING A NICE ROUND SHAPE WHILE KEEPING A NATURAL RESULT. BY CHOOSING ONLY A FEW ELEMENTS AND JUXTAPOSING THEM EVENLY, WE WILL END UP WITH A COMPOSITION THAT'S IDEAL FOR A CARD.

The plants

The main colors

Mix No. 2

Mix No. 3

Mix No. 4

Mix No. 6

Mix No. 7

Mix No. 9

Mix No. 11

Mix No. 15

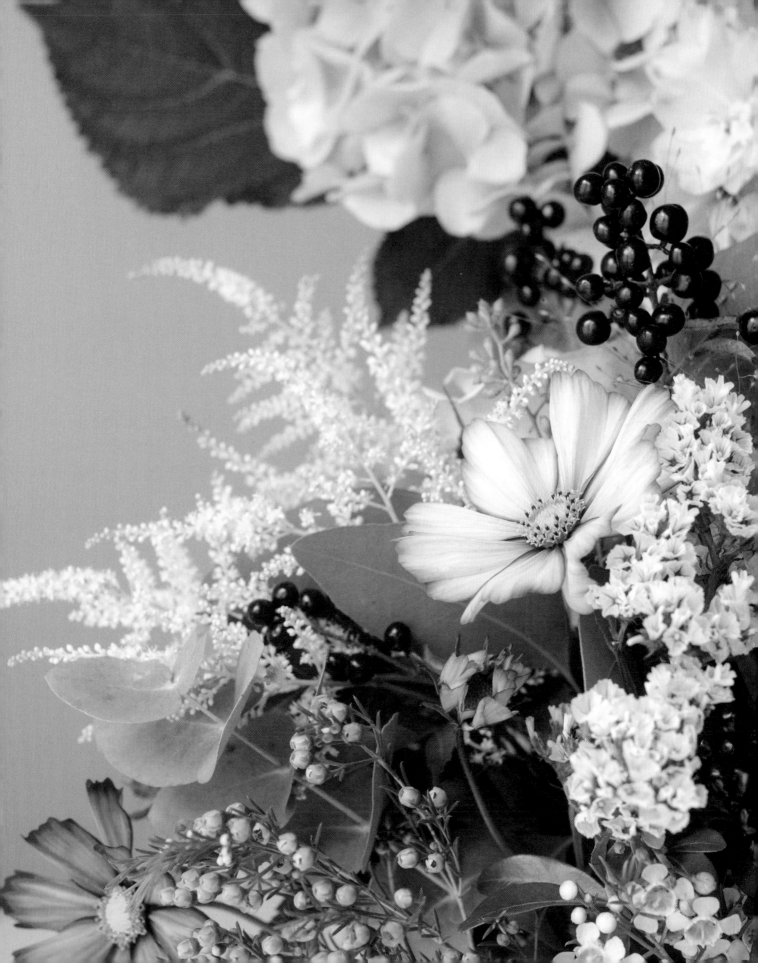

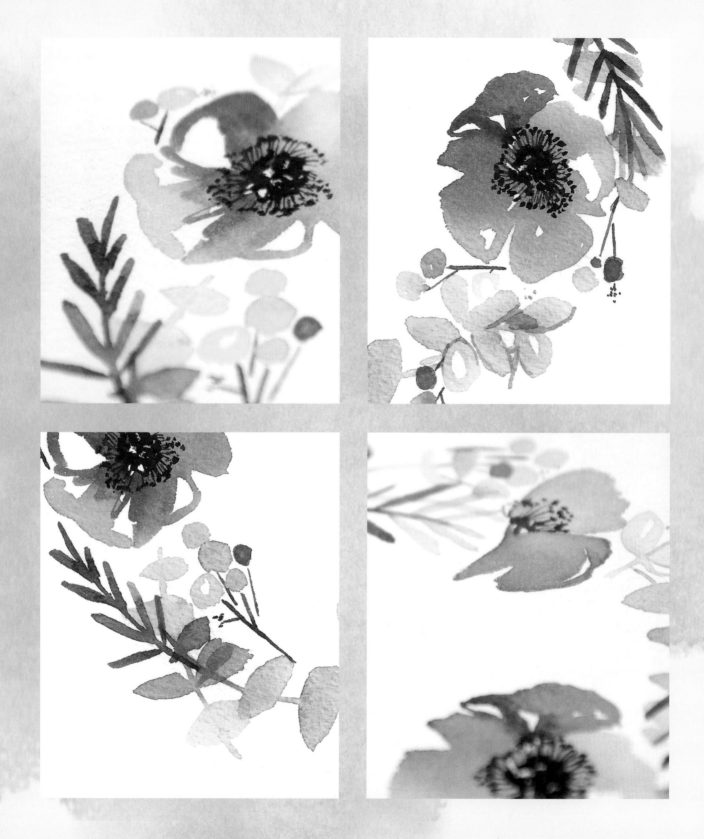

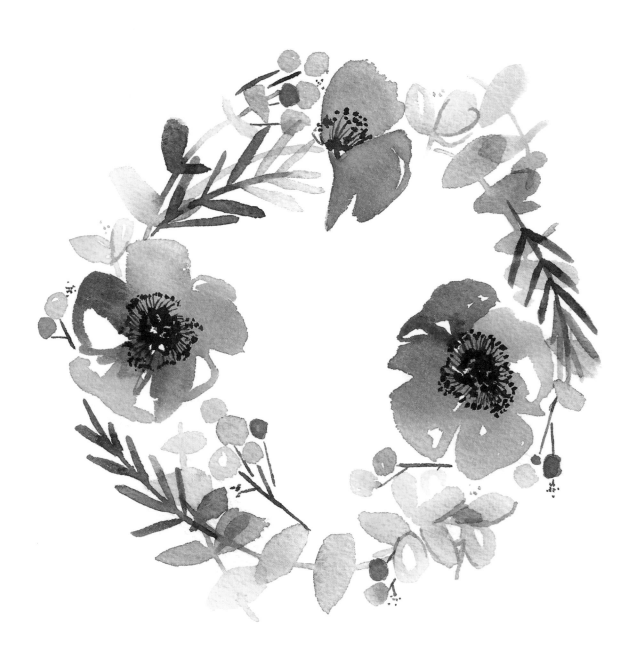

1 /

Let's start the circlet by painting the anemones (mix Nos. 6, 9 and 15). Paint them from different angles (including one from the side) and don't forget to leave white spaces.

2 /

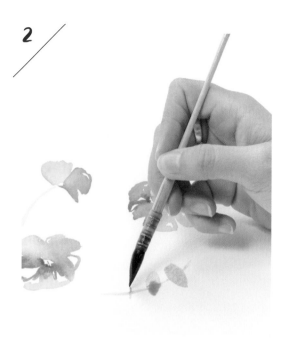

Paint the stem of the anemone viewed from the side and the first branch of eucalyptus (mix Nos. 7, 11 and 3). These two elements will provide the round shape of the circlet.

3 /

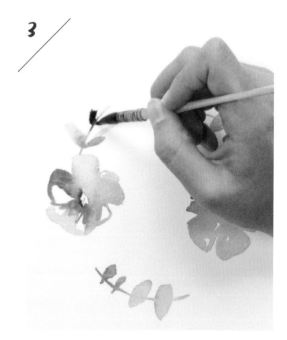

Let's continue with our composition by adding another eucalyptus branch. Vary the shapes, values and colors of the leaves to add relief. Try to leave blank spaces for the next flowers and leaves.

4 /

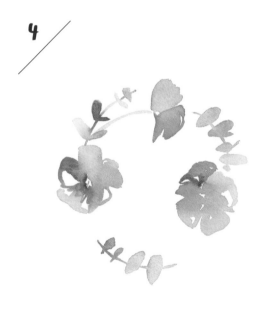

The third eucalyptus branch reinforces the circlet's shape. Note that the elements are heading in a clockwise direction. Choosing a direction for your circlet will give it more coherency.

5

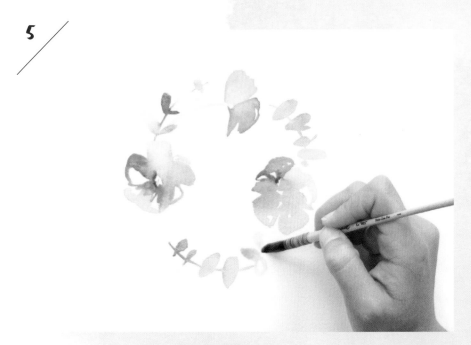

Now arrange clusters of hortensia flowers (mix No. 2, bordering on orange).

6

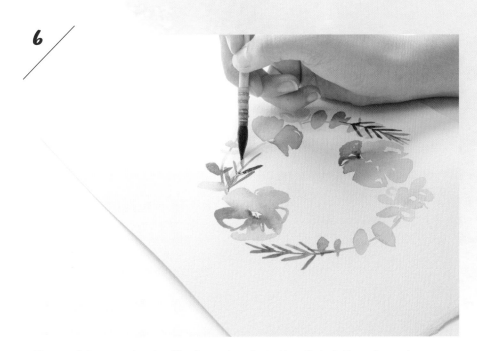

Then paint several palm-like branches (mix No. 4). Let these branches overlap with the eucalyptus, making sure that the previous layer is dry first.

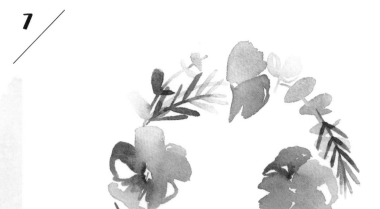

The new branches and hortensia flowers round off the structure of the circlet.

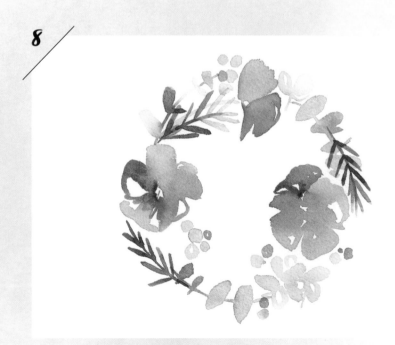

Arrange little colorful balls all round the circlet for extra detail. The colors used are similar to those of the anemones and hortensias.

9

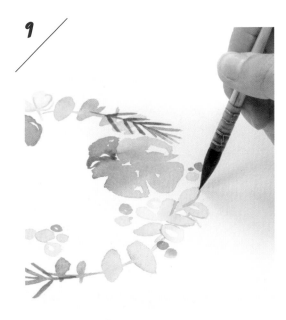

Outline the contours of some of the hortensia flowers using the tip of your brush and a violet mix (No. 9).

10

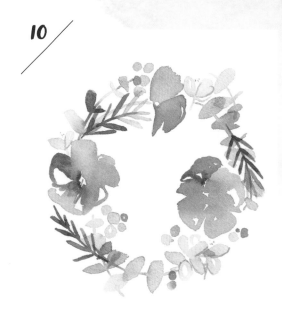

Add a few final eucalyptus leaves where the circlet looks a bit bare. Once the main layers are dry, we can play with overlays.

11

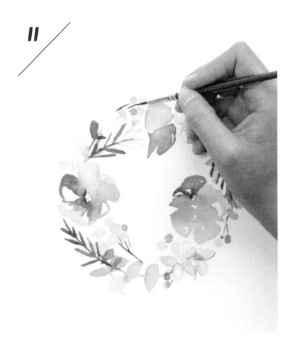

Add the stems of the small elements using a fine brush and a quite concentrated mix (No. 4).

12

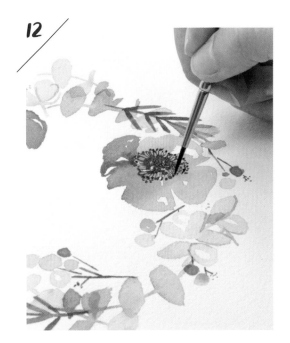

Finish your composition by painting the centers of the anemones using Payne's Gray. They are not all fully visible.

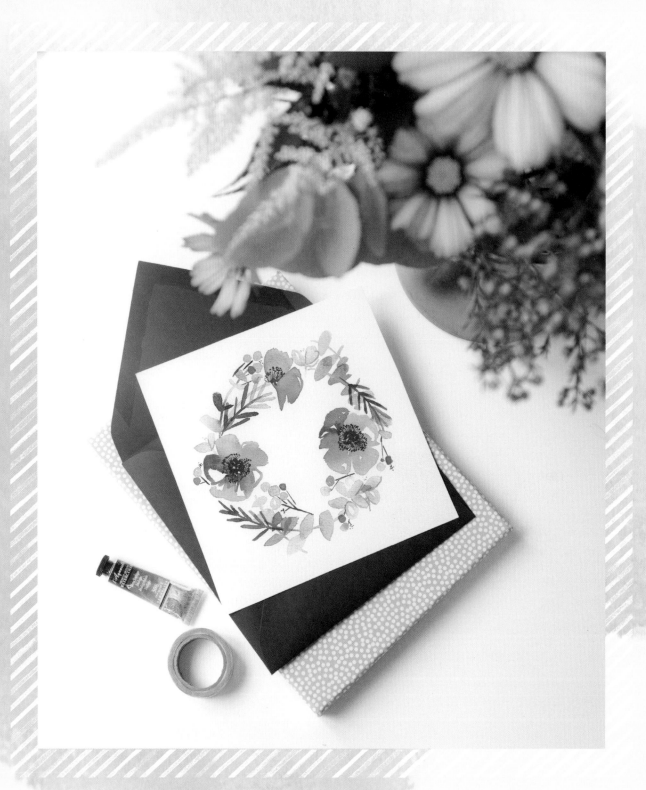

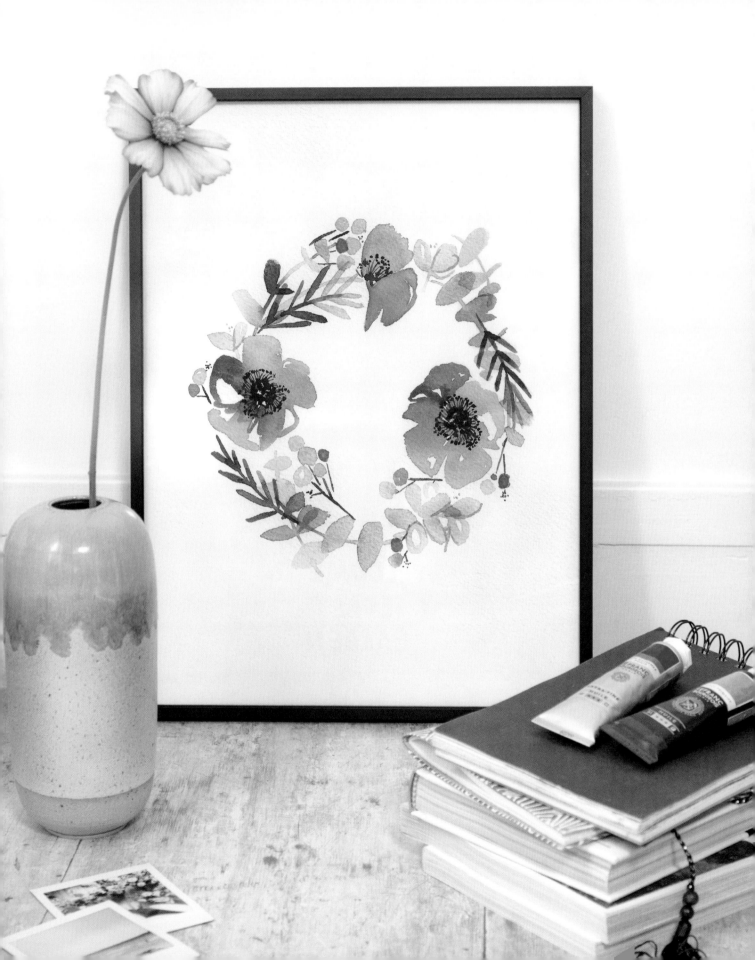

Colorful bouquet

ALTHOUGH A BOUQUET IS THE STANDARD COMPOSITION FOR FLOWERS, IT IS NOT EASY TO DEPICT. THE MAIN AIM IS TO COMBINE DIFFERENT HEIGHTS OF FLOWERS AND LEAVES TO CREATE A SENSE OF BALANCE. DELPHINIUMS AND LARGE FLOWERS WILL HELP US TO ACHIEVE AN OVERLAY EFFECT AND ADD DEPTH.

The plants

Dahlias page 62

Delphiniums page 77

Poppies page 66

Foliage page 68

The main colors

Mix No. 1

Mix No. 4

Mix No. 5

Mix No. 6

Mix No. 8

Mix No. 12

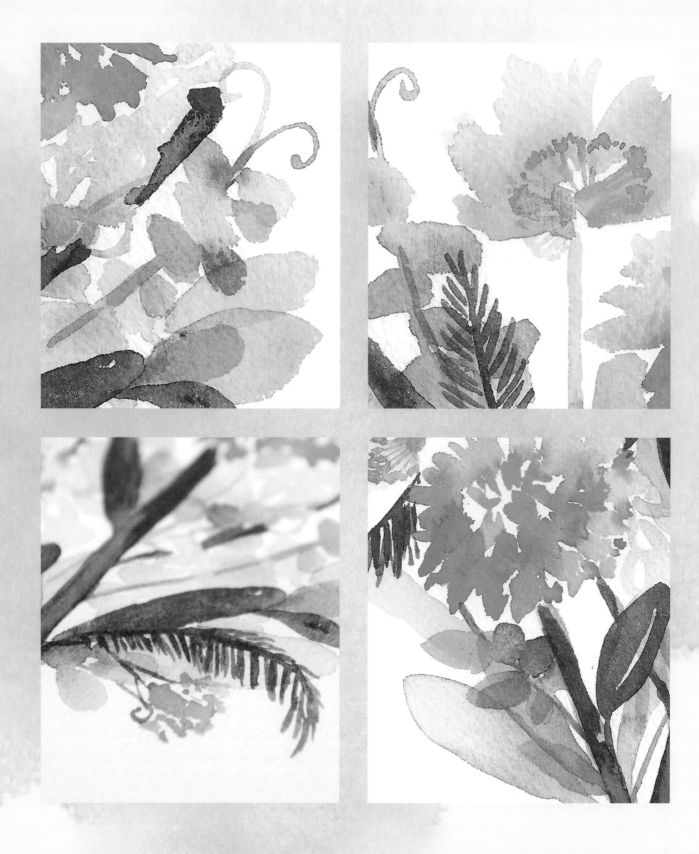

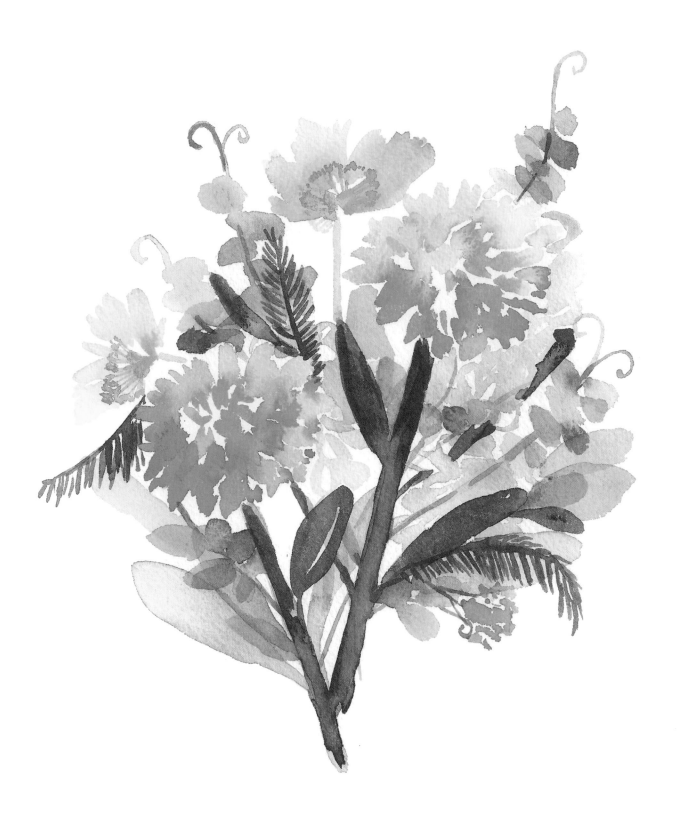

1

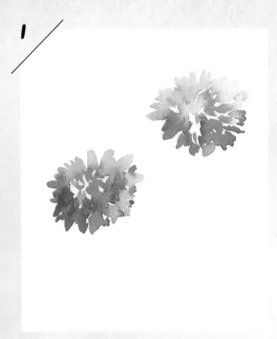

Start by painting dahlias, using mix Nos. 5 and 12, at different heights.

2

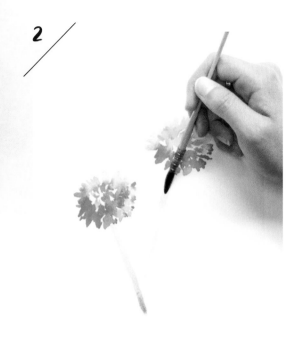

Then paint diagonal flower stems using a diluted Forest Green. Use the whole brush head and press down well.

3

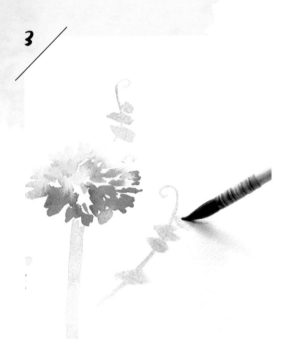

Let's start painting the delphiniums. I love these flowers as they are perfect for filling out a composition without being in the foreground. They merge with the foliage.

4

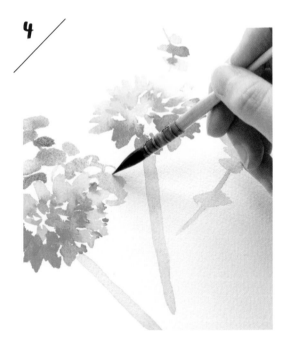

Continue painting several delphiniums behind the dahlias. Rinse your brush and use a pale pink color to paint the flowers. Alternate between filled-in and hollow shapes to add definition to the flowers.

5 /

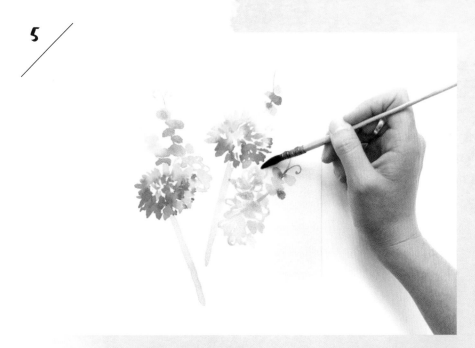

Continue working on the delphiniums before the first ones have time to dry in order to create lovely blending effects. I decided to make two of them pink and one violet, for more variety (mix No. 6).

6 /

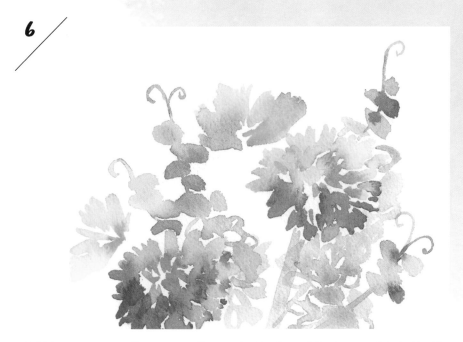

Add two orange-yellow poppy flowers to the top of the bouquet (mix No. 8).

7

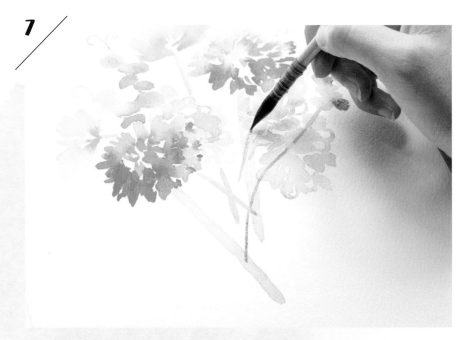

Paint thinner stems in a fairly light green (mix No. 1). You can always go back over them if you need to make the color deeper later.

8

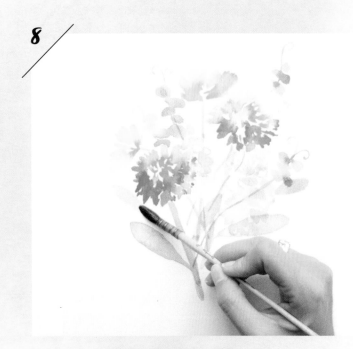

Then add some large round, transparent leaves using Forest Green. Angle them upwards to accentuate the bouquet's shape.

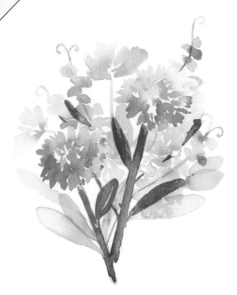

Go back over the stems and several leaves in a concentrated green mix to pick out the different levels and planes in the bouquet (mix No. 4).

Then paint clusters of leaves, using a light yellow-green (mix No. 1). They are reminiscent of the buds at the end of the delphiniums. Don't forget to create color gradations by adding more concentrated pigments near the stem.

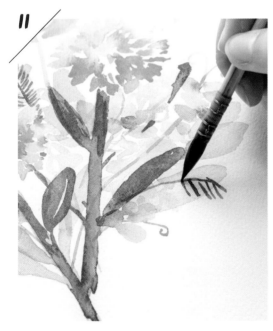

To add lightness and detail, paint palm-like leaves. Use the tip of your brush or a fine brush. You can hide part of the leaves behind flowers for greater depth.

To finish, I added a detail to the bottom right of the bouquet in red, picking up on the color of the dahlias, as I thought this area looked too green.

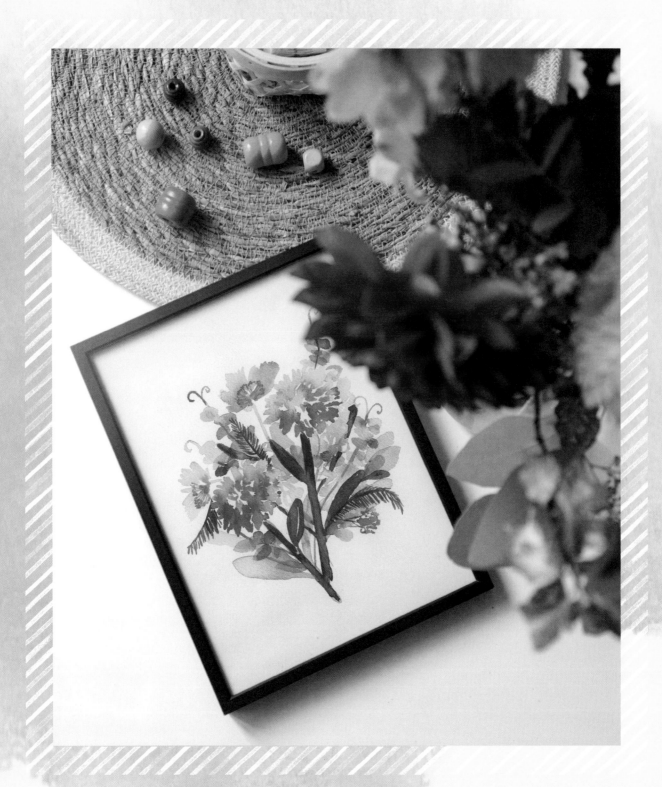

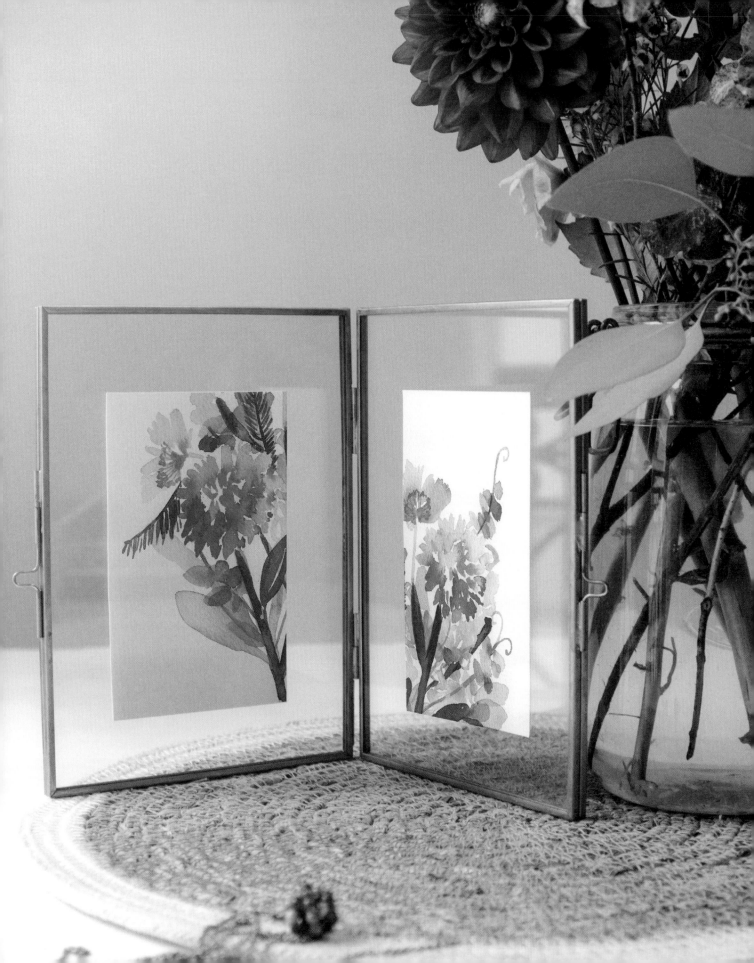

Peony pattern

A PATTERN IS A FUN COMPOSITION TO CREATE. THE AIM IS TO SCATTER THE VARIOUS ELEMENTS ACROSS THE SURFACE OF THE PAPER IN ALL DIRECTIONS. TO MAKE IT EASIER, I'VE ONLY SELECTED A LIMITED NUMBER OF ELEMENTS. WE WILL SHOW THEM FROM SEVERAL ANGLES AND IN DIFFERING HUES TO ADD VARIETY.

The plants

The main colors

Mix No. 1

Mix No. 2

Mix No. 3

Mix No. 4

Mix No. 8

Mix No. 9

Mix No. 13

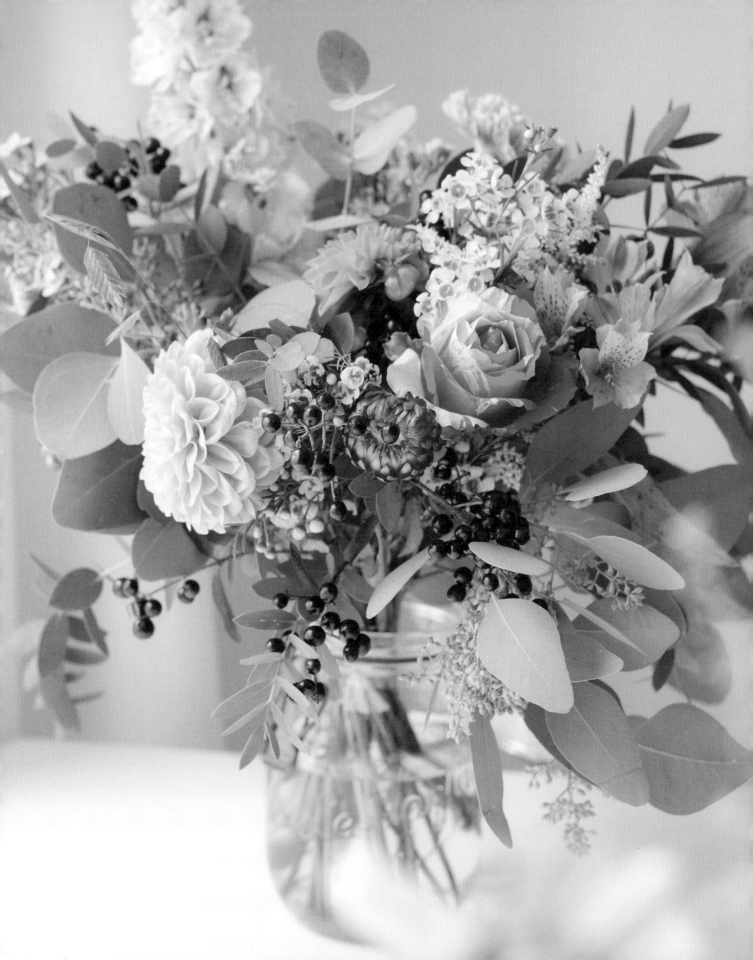

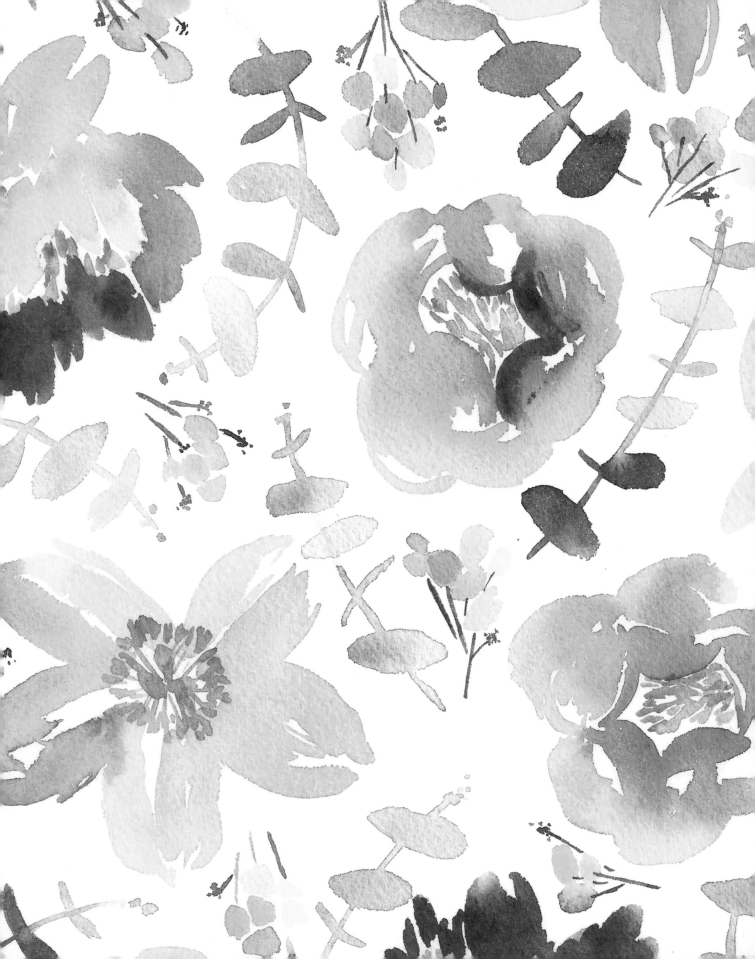

1 /

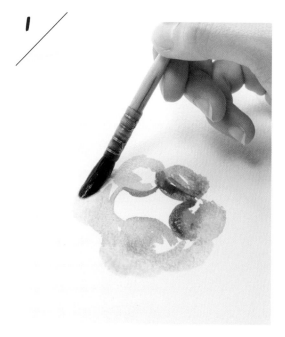

Before starting, stick masking tape along the edges of your sheet. As the pattern is quite busy, this will give the composition an airier feel. Paint the first peony, half-closed and viewed from above (mix Nos. 9 and 2).

2 /

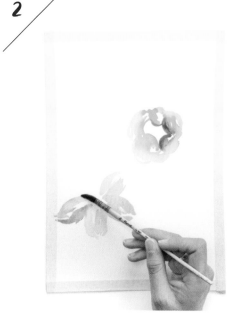

The second peony is opened up and seen from above. Changing viewpoints adds interest. Vary the colors slightly with each brushstroke (Opera Rose and mix No. 2).

3 /

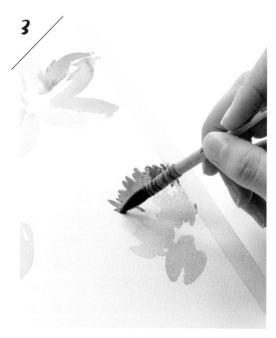

Paint on the masking tape to give the impression of the pattern continuing beyond the frame; here it's a peony viewed from the side.

4 /

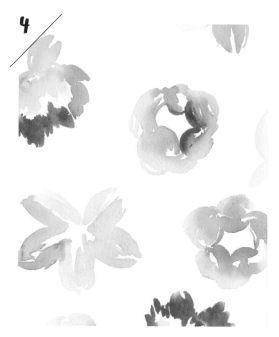

Leave enough space between the flowers to paint in the leaves later. Turn your sheet around several times to distribute the flowers in a balanced way.

5

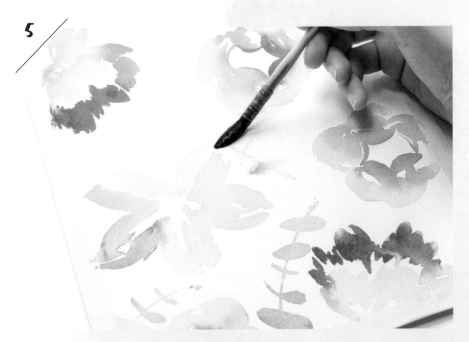

Start painting the branches of eucalyptus in between the peonies (mix Nos. 3 and 13).

6

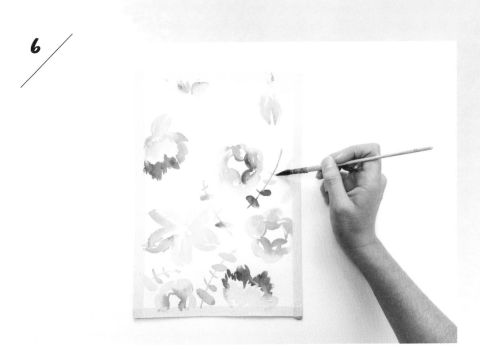

Vary the colors and shapes of the leaves, while avoiding tones that are too saturated. As the peonies already have vibrant, saturated colors, the more neutrally colored leaves (thanks to the sepia) balance the composition.

7

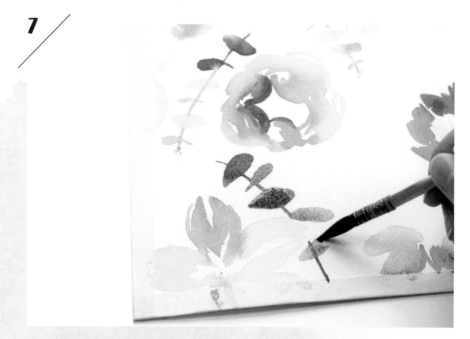

Feel free to paint leaves under the flowers or on the masking tape (mix No. 4).

8

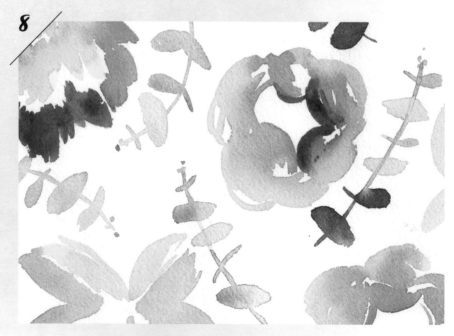

The branches are slightly curved to bring movement to the pattern.

9

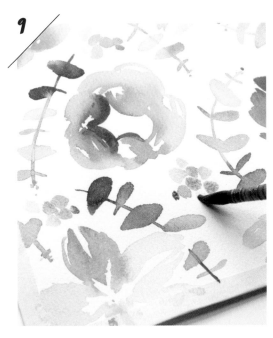

Fill out the composition by adding little clusters of balls in yellow-green tones (mix No. 1).

10

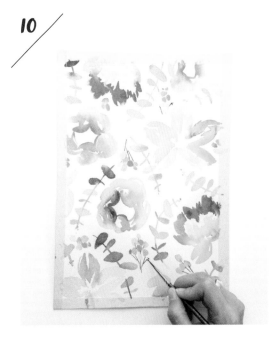

The line of the stems adds a lot of movement to the composition. Make sure they point in different directions (mix No. 3).

11

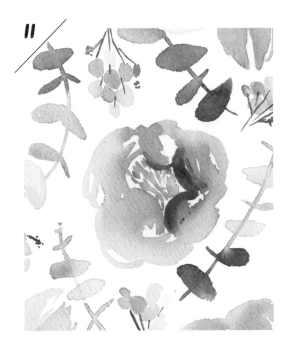

Add the center of the peonies as shown in the Plant Directory section (mix No. 8).

12

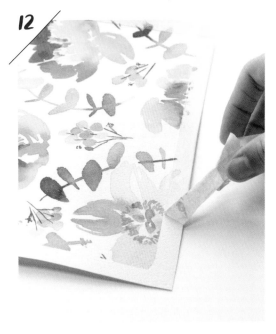

Once everything is dry, remove the making tape edging to see the finished result.

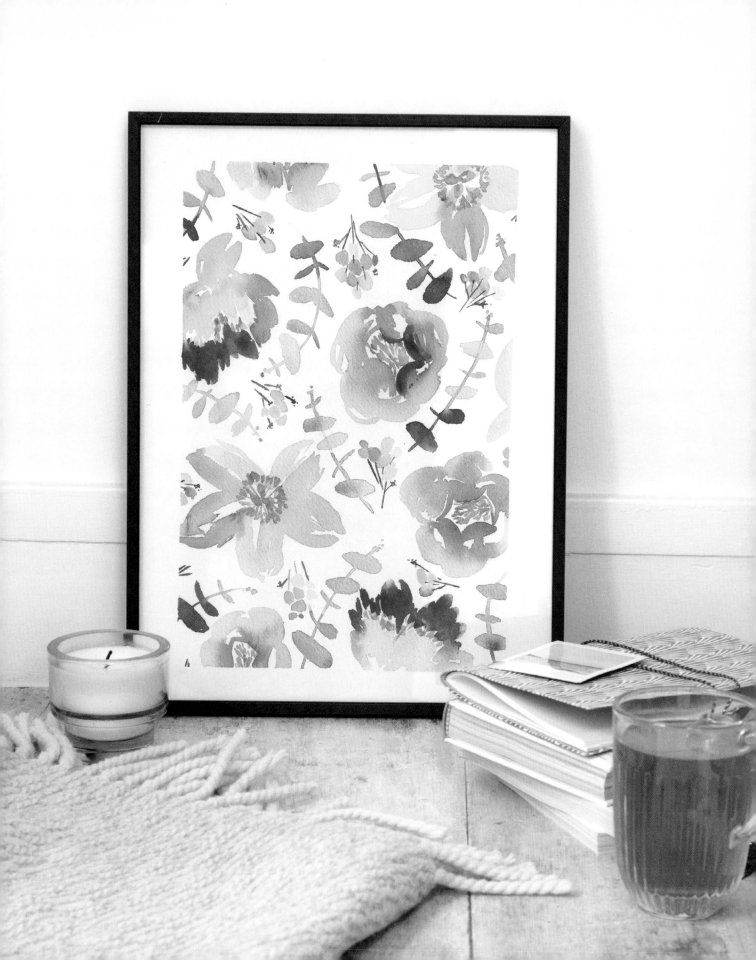

Poppy streamer

IT'S HARD TO FIND A STREAMER OF FLOWERS IN NATURE, BUT THEY CAN BE CREATED WITH BRUSHES, SO LET'S NOT DEPRIVE OURSELVES OF THEM! MOVEMENT IS WHAT MAKES THIS COMPOSITION INTERESTING. EXAGGERATE THE CURVATURE OF THE LEAVES AND STEMS TO CREATE THIS WONDERFUL "S" SHAPE. ALSO EXPERIMENT WITH THE BEAUTIFUL ANALOGOUS TONES IN THE BOUQUET SHOWN OPPOSITE: YELLOWS, ORANGES, PINKS....

The plants

Poppies page 66

Astilbes page 79

Foliage page 68

The main colors

Mix No. 1

Mix No. 2

Mix No. 7

Mix No. 10

Mix No. 12

Mix No. 13

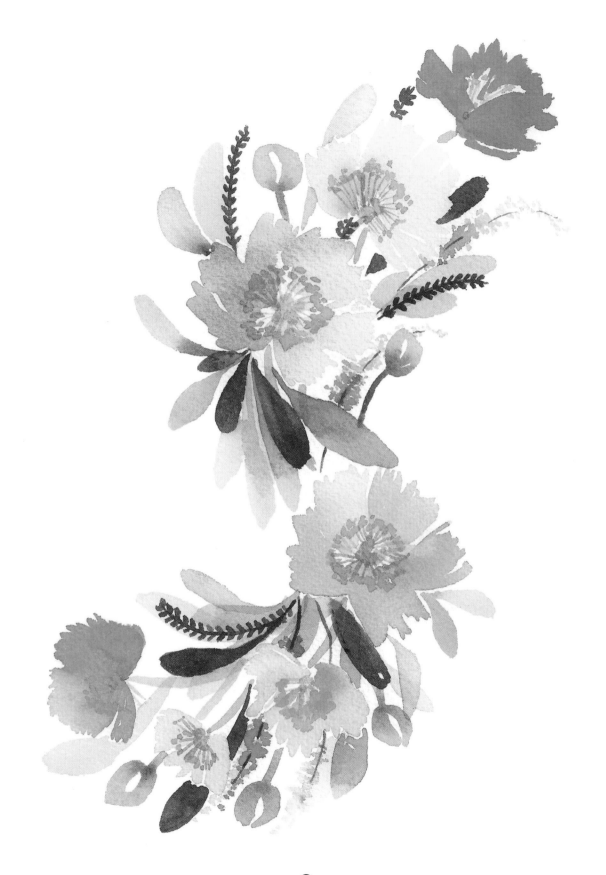

1 /

Start by painting the first poppy using an intense Quinacridone Yellow. This poppy will be a major focal point in the composition.

2 /

Paint two more, smaller poppies facing the same direction, on the upper section of the "S". The first is in mix No. 10 and the second in mix No. 12.

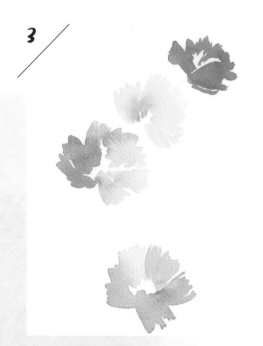

3 /

Then paint the main poppy in the second part of the "S" using mix No. 2.

4 /

Turn your sheet and paint two more small poppies in the bottom section of the "S". Don't forget to leave white spaces to add light to the flowers.

5 /

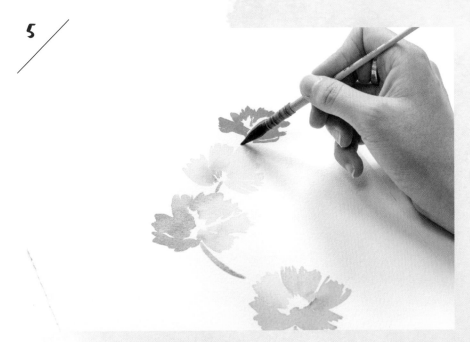

Paint the stems using a yellow-green mix (No. 1). They should be curved and follow the shape of the streamer.

6 /

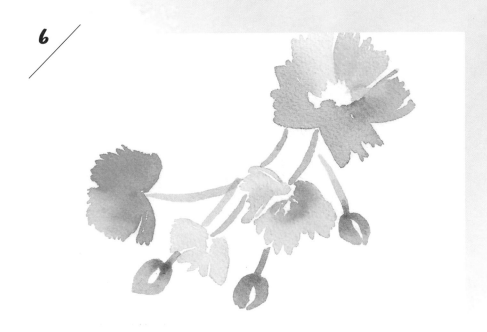

Paint poppy seed pods, first using a light yellow-green and then adding some concentrated Sap Green to create a gradation effect.

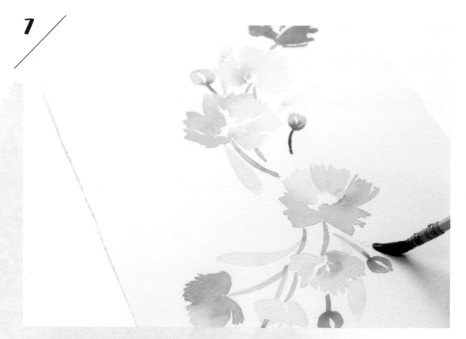

Paint long leaves using some of mix No. 7. The direction of these leaves is important as it lends shape to the streamer.

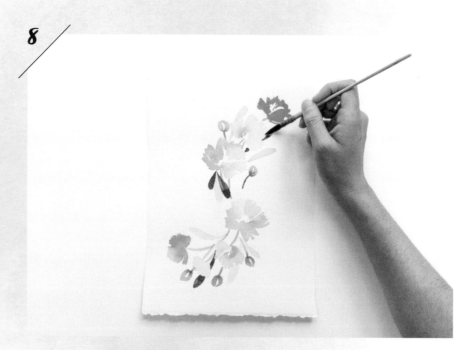

As the composition structure is quite delicate, paint simple leaves of the same type for greater clarity. Vary the values and create overlays.

9

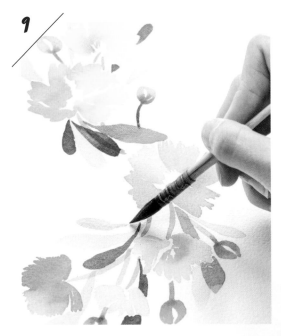

A set of smaller leaves in a green midtone (mix No. 13) will complete the structure of the composition. The direction of the leaves is very important for creating the desired effect of movement.

10

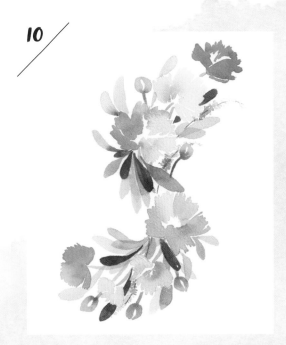

Astilbes help to balance the composition, which up to now had slightly less at the top than at the bottom.

11

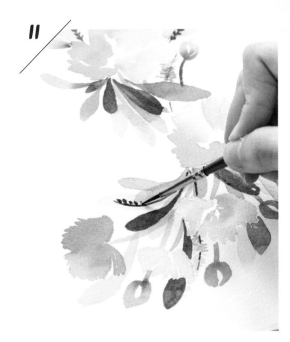

Using concentrated sepia, add palm-like stems but with very short leaves.

12

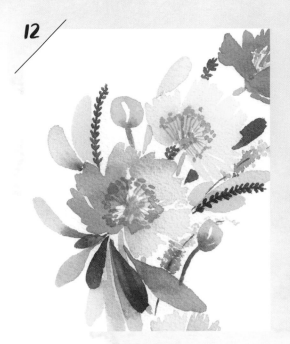

To finish off, add the centers of the six poppy flowers using a mix of Lemon Yellow and Quinacridone Gold, as well as a dot of Sap Green.

Index

DIRECTOR: Guillaume Pô
EDITORIAL DIRECTOR: Tatiana Delesalle
PUBLISHER: Hélène Raviart
ARTISTIC DIRECTOR: Chloé Ève
GRAPHICS AND LAYOUT: Caroline Soulères
PRODUCTION MANAGER: Thierry Dubus
PRODUCTION OFFICER: Florence Bellot
PHOTO ENGRAVING: SNO

Portrait of the author on page 8: Noémi Micheau
Flowers: Pampa

Thanks

I warmly thank my family, Alex and the faithful
readers of my blog for their encouragement,
having made this project possible.